WITHDRAWN

A unique portrait of Pablo
Casals, without the maestro.

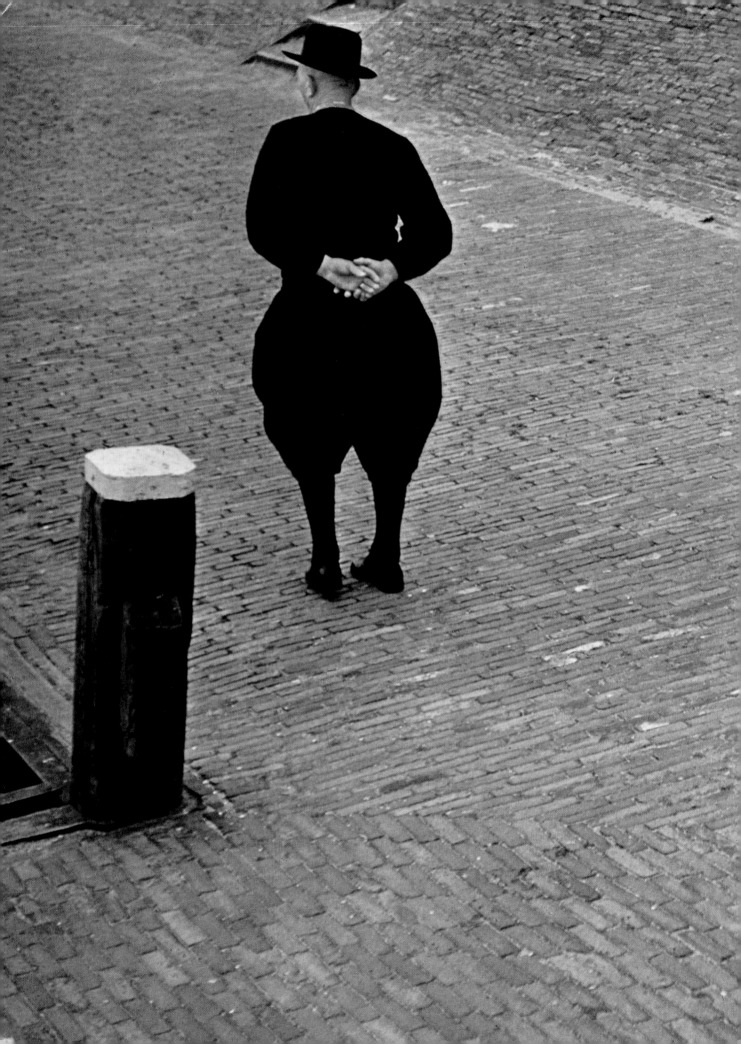

MASTERS OF CONTEMPORARY PHOTOGRAPHY

the Private Experience: Elliott Erwitt

text by Sean Callahan
with the editors of Alskog, Inc.

Prepared by Alskog, Inc.
Lawrence Schiller / Publisher
William Hopkins / Design Director
John Poppy / Executive Editor
Vincent Tajiri / Editorial Director
Julie Asher / Design Assistant
Arthur Gubernick / Production Consultant
Jim Cornfield / Technical Consultant

An Alskog Book
published with
Thomas Y. Crowell Company, Inc.

Library of Congress Catalog Card Number: 74-8232
ISBN: 0-690-00624-1 Soft cover
ISBN: 0-690-00623-3 Hard cover

First Printing
Published simultaneously in Canada
Printed in the United States of America

*Erwitt's telephoto lens
foreshortened perspective
to produce strong design
in this advertisement
for Holland.*

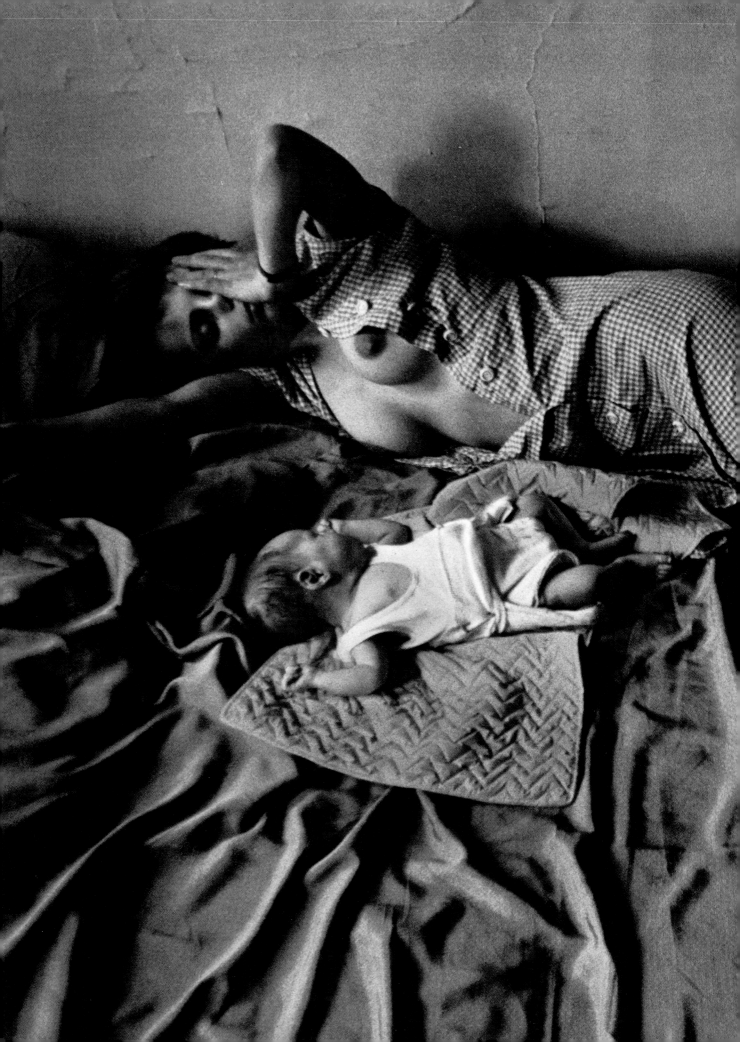

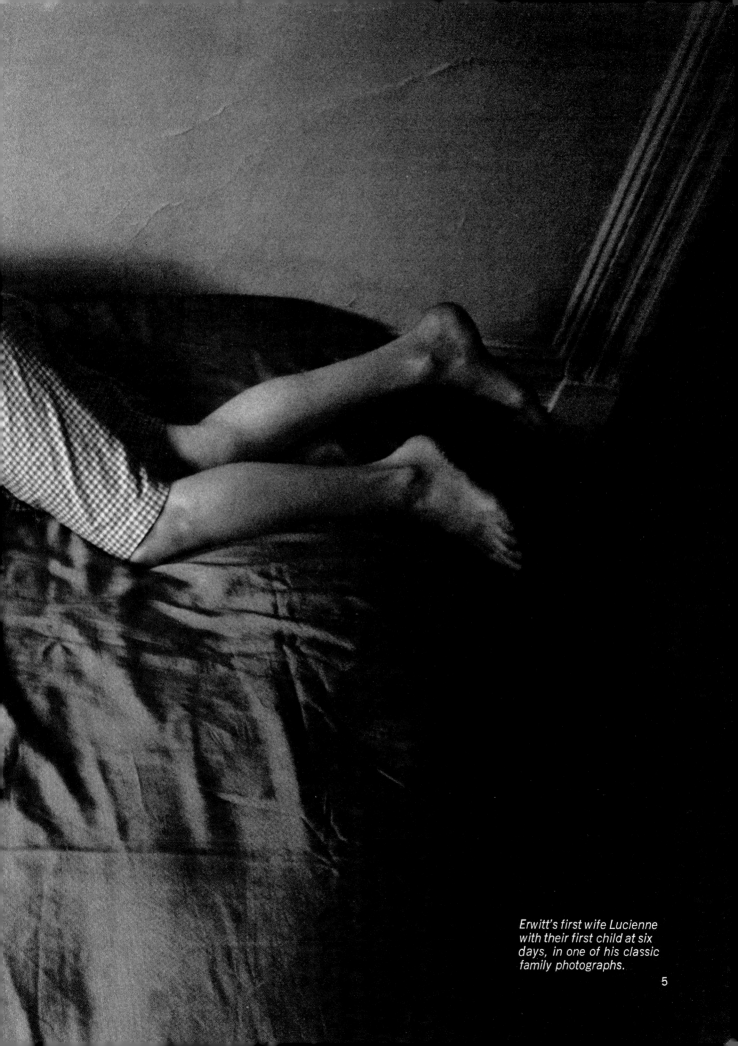

Erwitt's first wife Lucienne with their first child at six days, in one of his classic family photographs.

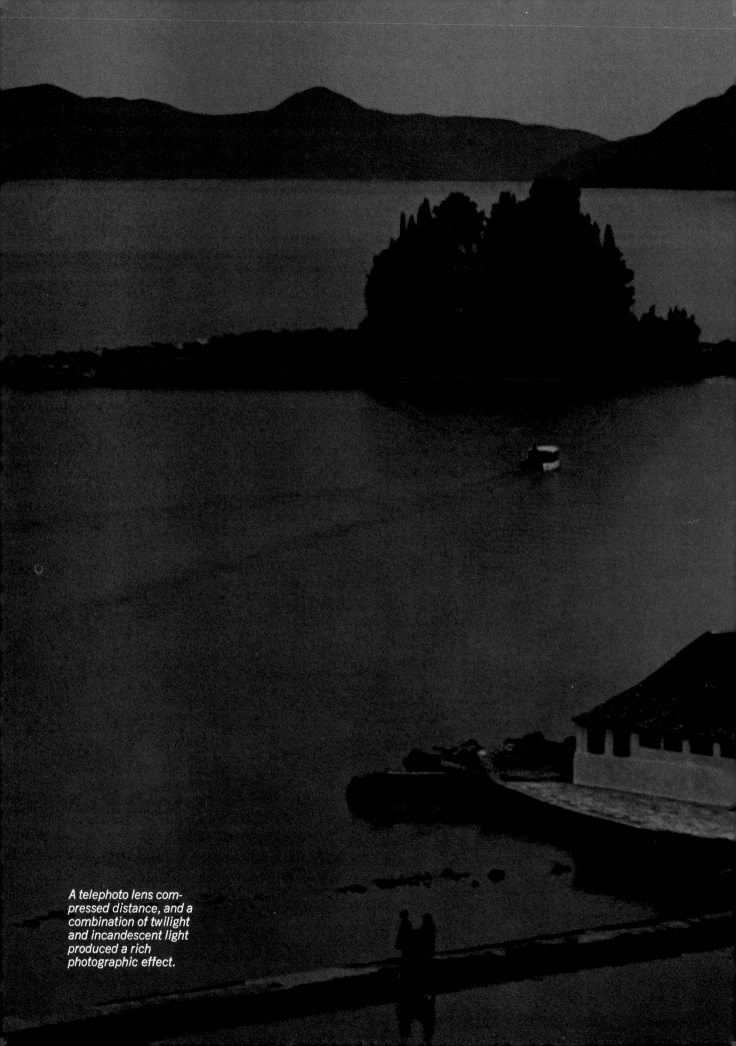

A telephoto lens compressed distance, and a combination of twilight and incandescent light produced a rich photographic effect.

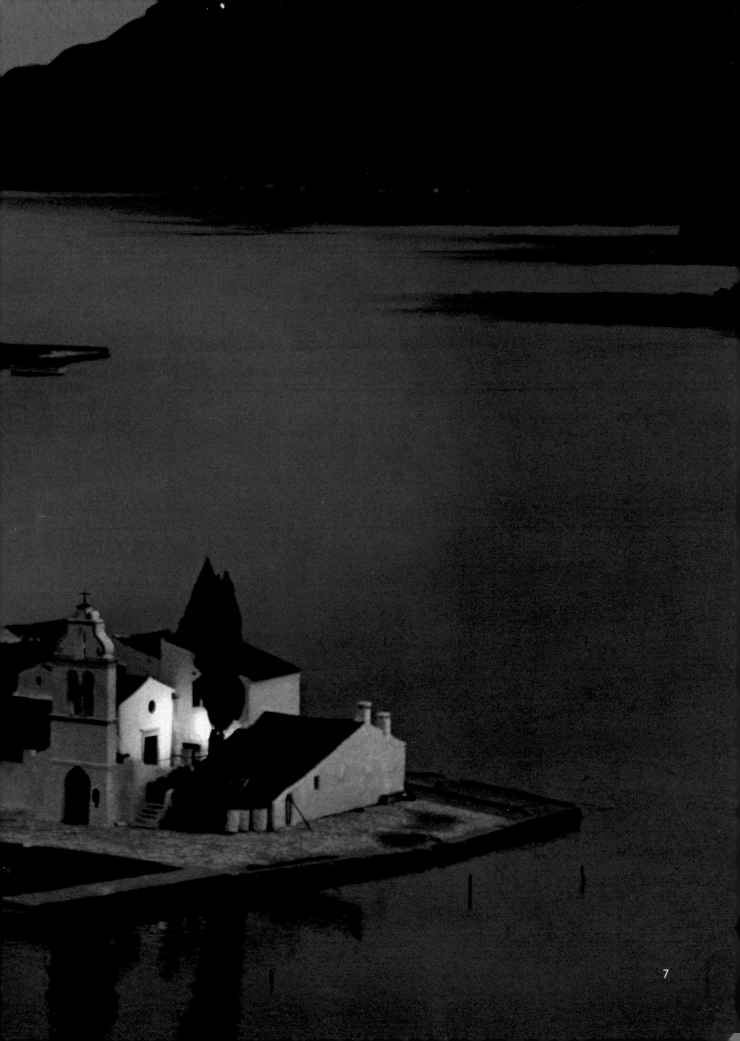

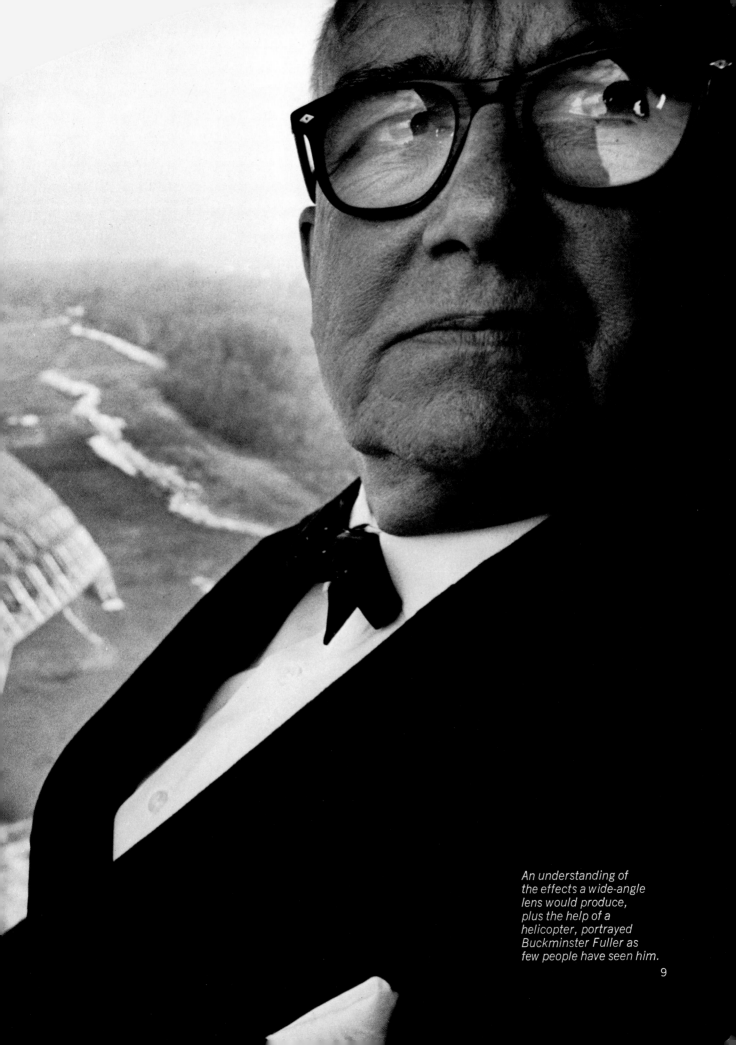

An understanding of
the effects a wide-angle
lens would produce,
plus the help of a
helicopter, portrayed
Buckminster Fuller as
few people have seen him.

9

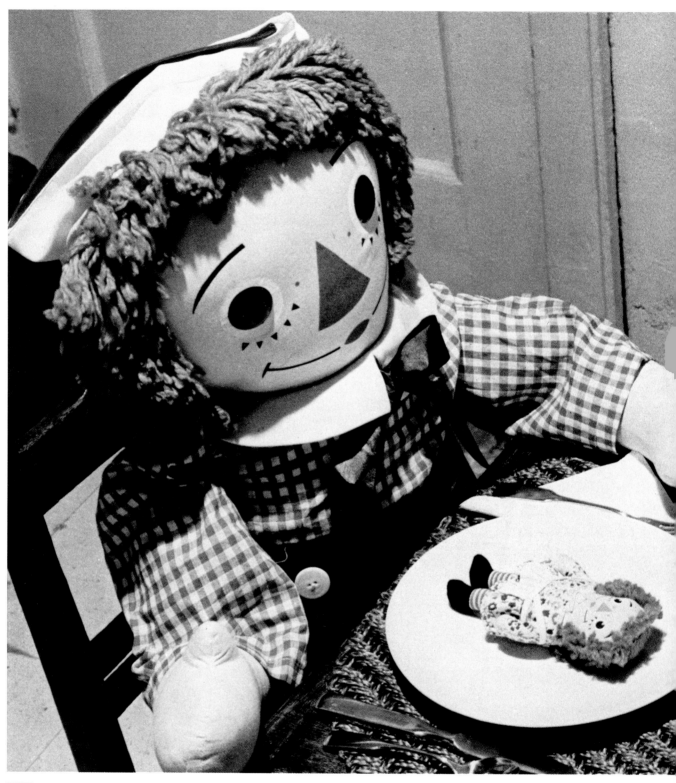

Introduction

As a form of serious photography, personal pictures are far less familiar to non-professionals than the more public forms—illustration, journalism, essays, portraits, studies of the human figure in action—with which professionals make their living. Paradoxically, though, they are probably the most common kind of photograph in the world. Nearly every family has its snapshots that preserve parts of its members' lives. There are ways in which the snapshooter can improve his or her eye to add dimension to the experience; mastery of such techniques marks the private moments of one of the world's leading photographers.

Elliott Erwitt is a photographer who separates his picture-taking into two

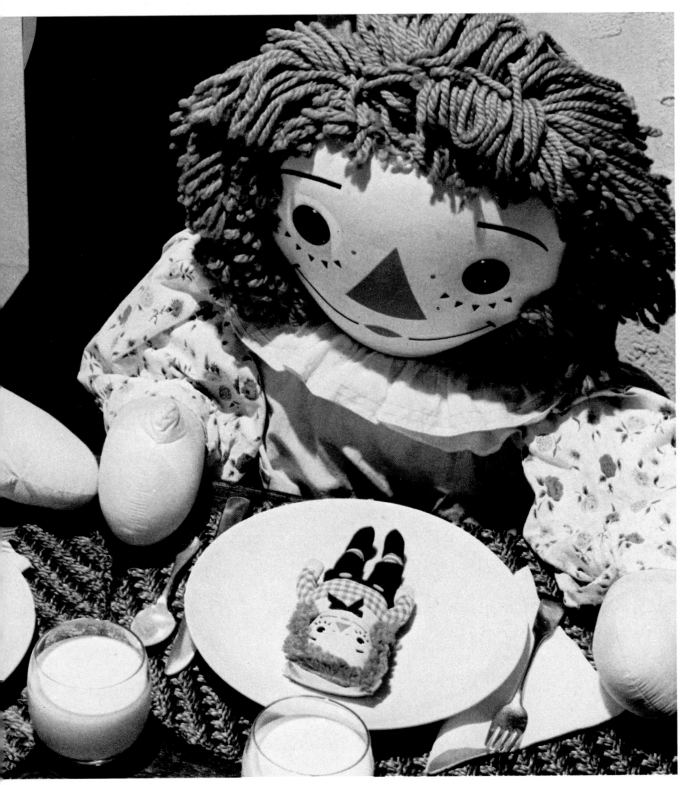

sides, professional and personal. "It's not that I hate one and love the other," he says, "it's just that they are separate. I'll always be an amateur photographer." The word "amateur," as Erwitt uses it, comes from the Latin for "love."

Like Erwitt himself, many of these photographs project a wit, a smile at the edge, that adds a universal charm to their incisiveness, lifting them into a realm where they seem to tell us something of the entire human experience by looking at small slices of the world.

This portrait of a private photographer owes much of its strength to the help of other photographers including Ernst Haas and Henri Cartier-Bresson; museum curators including

An interpretation of dolls at Christmastime for Life.

Eugene Ostroff and John Szarkowski; advertising executives including David Ogilvy and Bill Bernbach; Erla Frank Zwingle; and of course, Diana and Elliott Erwitt.

11

Grabbing photographs between two worlds

The West Side of Central Park is lined with staid but stately apartment buildings, all but one built before World War II. Number 88 is typical. The building reflects the quiet self-assurance of the tenants who own it. It says success, recognition, prestige, but doesn't shout it.

Living here, among others, are a television producer, a recording executive, an actress, a novelist, and a photographer. A visitor tells the doorman he has come to see Elliott Erwitt. He phones up.

"Speaking."

"Mr. Erwitt?" the doorman asks, not realizing his question has already

been answered. The wit of Elliott Erwitt is verbal as well as visual. Like his photography, it is swift and subtle.

The jest confuses the doorman. He is new to the job, and has not seen much of Erwitt. One must see a lot of Erwitt in order to appreciate both him and his pictures. Catching the man at home is a rare event. But he is just back from his latest advertising job in Europe, has just completed a movie, and is finishing printing pictures in his home darkroom for an exhibition. So his wife Diana has just scheduled a party to re-introduce Elliott to their friends, and the visitor has jumped at the chance of seeing him at rest.

The doorman directs the visitor to a small elevator. Riding up he notes that at first he was just as confused by Erwitt's pictures as the doorman was by Erwitt's quip. The photographs are so damn casual. So slight. Understated. John Szarkowski, the Museum of Modern Art's Director of Photography, once said, "They deal with the empty spaces between happenings—with anti-climactic non-events." Perhaps to help the viewer understand, Erwitt has allowed them to be called "Anti-Photographs." When assembled in a book or exhibit, their collective impact is not so slight. Some will call them grab shots. But look how often he grabs, and look how often he gets.

Then there is the biting wit of Erwitt. When *Life* magazine asked him to make a picture of dolls for a feature in their annual Christmas issue, Erwitt served up his own modest proposal to deal with the over-population problem of dolls at that time of year. He seated a Raggedy Ann and a Raggedy Andy at a dinner

table, about to devour two little Raggedies.

These photographs of "non-events" ("snaps," he is known to call them) are part of the private world of Elliott Erwitt. Tonight's party is for the public world where he is known as a most-sought-after advertising photographer. His lyrical pictures for the Irish Tourist Board are described as "what you want Ireland to be all about." ("Postcards," he is known to call them.)

These two worlds, antithetical as they are, are also supportive. One depends on the other. Such schizophrenia has driven other photographers—W. Eugene Smith, Robert Frank, even the young Danny Lyons—into isolation and self-imposed exile. Erwitt has somehow been able to meld the private and the public into a unique lifestyle and a highly profitable career, and the visitor has come to find out how.

Erwitt is reluctant to provide the answer—not that it might be a professional secret. It is just that he is notoriously laconic. Once a writer was telling a colleague of Erwitt's that he hoped to do a book of about 12,000 words on Erwitt. "My God, man," the other photographer said, "in all the years I've known him, Elliott hasn't *spoken* 12,000 words."

The elevator stops at the Erwitts' floor and the doors open on a small foyer. The visitor takes half a step out and freezes. Good Christ, it's a moose. Up there on the wall, crowding this tiny room and this visitor, is a huge stuffed head. The elevator leaves, sealing the visitor in, while he fumbles absently with the doorbell. He begins count-

Elliott Erwitt at the 1968 Republican national convention.

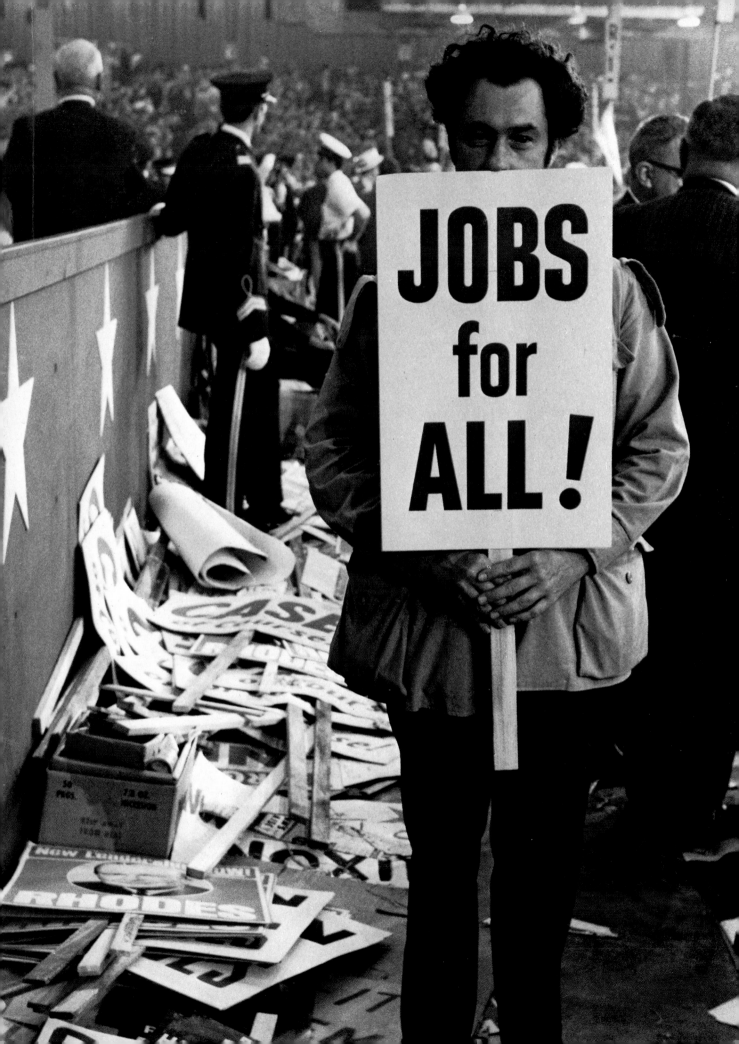

ing the points on the antlers, reaching 16 on one before the door flies open.

"Hi, come on in," says the implausible figure in the doorway. Could this be Elliott Erwitt? "I'm Elliott Erwitt." Of medium height, he is wearing sandals, baggy corduroy slacks and jacket, and a rumpled black cotton turtleneck. A bewitching smile beams around his face, punctuated by a long, skinny cigar. But it's the hair. Kind of ofay-Afro, thick black curls that pile up on his head forming a helmet.

Diana Erwitt appears. A tall, blonde, beautiful Swedish-Irish American, she guides the visitor through the party while Elliott disappears to make drinks. Already here are two movie directors, one producer, the managing editor of a newsweekly, a prize-winning journalist and his Polish actress wife, several writers, and a small, solidly-built septuagenarian who sits at the periphery, smiling broadly and listening intently to all conversations at once. He is a Buddhist priest, the Rev. Boris Erwitt, Elliot's father.

The sparsely decorated living room is massive, exulting in open space and offering a panoramic view of Central Park. In another time, Jefferson would have enjoyed this room. Off of it is a game room where an electronic pop art piece flashes intermittently, and where several Erwitt children are taking turns hustling the

guests at pool. Two of Elliott's children by his first marriage are here tonight, along with Diana's son by her first husband. The visitor wisely declines an offer to play the next game and returns to the party.

Elliott has reappeared with his hair combed down. Diana is proudly showing off a pendant made from a large, round gemstone that they picked up on their last trip to Europe. Elliott immediately likens it to a shower soap, and begins to apologize profusely for Diana who, he says, has just stepped out of the bath. He disappears again while the table is being readied, and when he reappears for dinner, so has his bushy hair.

Diana is a superb cook, and tonight's entrée is lemon shrimp, a recipe purloined from one of the most fashionable Chinese restaurants in New York. Somebody mentions that it must have been days in the making. Diana tosses the compliment as Elliott drapes a napkin over his head. One of the corniest gags in the world, but somehow he has made it look original. The guests are breaking up with laughter, while Elliott pretends to be nonplussed, fumbling with his chopsticks. He shows himself to be a gifted physical comedian, and the comparison to Chaplin is unmistakable—especially since Erwitt is a serious student of his films. There is the same economy of motion, the long pauses for effect, and the bushy hair.

Chaplin is more of an influence on Erwitt than he might admit. Erwitt has a penchant for photographing underdogs—graceless mutts that he encounters in his world-wide travels. Ernst Haas, his long-time friend and former colleague at Magnum, the distinguished

photographers' collective, says, "Stray dogs are for him a special object. He can find in them the lonely, grim life that reflects tremendously his feelings for humanity." Diana offers another view. She feels he identifies very strongly with the dogs. "He sees himself as one of those rag-tag mongrels, a little sad-eyed dog on his way to a great journey, or just stopping off for a few moments from one."

If anybody had an opportunity to live out Jackie Coogan's role of The Little Tramp, it was Elliott Erwitt. He was born of Russian émigré parents. His mother, Eugenia, came from one of the wealthiest families in Moscow, but they had to flee, penniless, after the Revolution. Boris was born a Jew in Odessa. He renounced formalized religion in his early years after witnessing a ceremony blessing cannons as they were being readied for use against the Germans in 1914. He remained an atheist until he discovered Buddhism at 16, and finally became a priest after studying in Japan in 1957. Eugenia left Russia for Italy before

they could marry. Boris, caught behind without identity papers, had to stow away on a freighter, hiding in the tunnel of the ship's driveshaft, where he nearly froze to death. They were re-united in Yugoslavia, married, and moved to Rome. Business took them briefly to Paris, where Elliott was born in 1928, and then back to Milan, where Elliott spent the next 10 years. When he was four the parents separated, and Elliott shuttled between their two homes until he was 15. He grew up a quiet, introspective boy, and it was quite some time before he spoke. Boris remembers that when he finally did, it was with extraordinary precision, as if he had waited until he had something to say. "Every word was pronounced exactly, fully, and never with any baby-talk," recalls his father. One day when Elliott was about four, he was playing with a friend who asked about a statue of Buddha in the corner. Elliott thought for a moment, and said, "Hard to

The young Erwitt at his Fountain Avenue house in Los Angeles.

14

An early Erwitt photograph taken in Los Angeles during his teens.

say what is Buddha. It is somebody who lived long ago, and he said that people should not be very unhappy."

By this time Boris had become a fur broker. He traveled a great deal, and asked his son to write him letters. When Elliott asked what he should write about, Boris encouraged him to document the seemingly insignificant details of his day, such as when he got up, what happened in school. . . . The child labored over these letters, polishing them into hard little nuggets of information that became models of journalistic prose. For a visually-oriented person, Erwitt is a prolific writer. Although his favorite medium today is postcards, they bear evidence of an uncommon deliberation over the choice of proper words—the same kind of attention he gives to poring over his contact sheets.

When Fascism became oppressive in Italy, Boris fled to France in 1938. Eugenia and Elliott soon followed. The war then began to threaten France, so Boris decided to immigrate to America. Some months after, on September 1, 1939, Eugenia and

Elliott boarded a ship for New York, too. It turned out to be the last passenger ship to leave free France.

At the age of 11, Elliott adopted his third country and his fourth language. He enrolled in P.S. 165 as a first-grader. The prospect of grasping another culture at such an early age might have been traumatic for most children, but Elliott, infused with his parents' sense of self-reliance, progressed rapidly through the grades. He learned English and achieved fifth-grade level by the end of the school year. In fact, school even bored him. As a quiet, shy little

boy, he developed a chameleon-like quality that serves him well today as a photographer able to keep his presence unknown. He would slip out of class unnoticed to spend the afternoon visiting Picassos, Magrittes and Modiglianis at the Museum of Modern Art, and then just walk into the movie downstairs.

Boris had found work as a traveling salesman, and Elliott moved in with him in a flat on the Upper West Side, visiting his mother on weekends, at the Fifth Avenue apartment where she lived with friends. One Sunday, Boris picked him up at the beach, where he had gone swimming. It was only supposed to be for a short ride, but Boris then and there decided that they should forge a new life together. With Elliott clad only in his swimsuit, with only a case of samples in the trunk and a few dollars in his pocket, Boris chose to drive to Los Angeles.

Their second night out, they were staying in a cheap motel outside Columbus, Ohio. He still hadn't told Elliott of his intentions. The boy was asleep in the bedroom, and Boris was wracked

with doubt. He had reached the fail-safe point. Columbus was the outer limit of his sales territory. There was no justifiable reason for taking the company car any further. His money was running out; he would have to live by his wits and off his samples. He had some acquaintances in Los Angeles, but surely no prospect for a job. From the bedroom came the voice of his 12-year-old son. "Papa, Papa, stop thinking. Everything will be all right."

They arrived in Southern California and settled in, of all places, Hollywood. Boris sold watches while Elliott attended Hollywood High, graduating when he was 16—a vital factor, he claims, in allowing him a head start on his career.

It was while he was growing up in Hollywood that Elliott first took to photography. He remembers being attracted to a gleaming, chrome-plated Argus box camera. A laundry room soon became a darkroom, and Elliott

25 years after the first A-bomb test at Los Alamos, Erwitt photographed the site for Esquire *and made this snapshot of himself.*

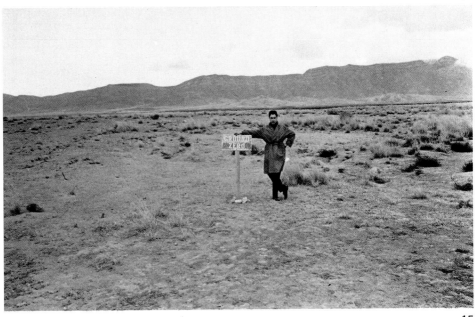

15

would disappear into it for hours. Once Boris got a large order for watches that needed to be engraved before Christmas. He taught Elliott how to do it, who in turn taught several of his young friends, thereby setting up a production line that netted Elliott over $200, with which he bought his first "real" camera —a Rolleiflex.

From the first, there was a bifurcation of Elliott's work. "I've always had a distinct vision of what I had to do for money, and what I had to do for pleasure." In the case of the former, it was shooting weddings and portraits for people in the neighborhood. The latter he describes as "artsy-craftsy" pictures that were "moody, somber and self-pitying—full of the kind of romantic introspection typical of all teen-agers." Yet Erwitt was far from the typical image of a Hollywood teen-ager. He admits to always having been a voyeur. Instead of joining the local world of convertibles, surfboards and muscle-flexing on the beach, he stood back and began to see his camera as a way to scrutinize it all.

Eugenia joined them in Los Angeles, and Elliott began the parental shuttle again. She got work as a waitress, and was quite

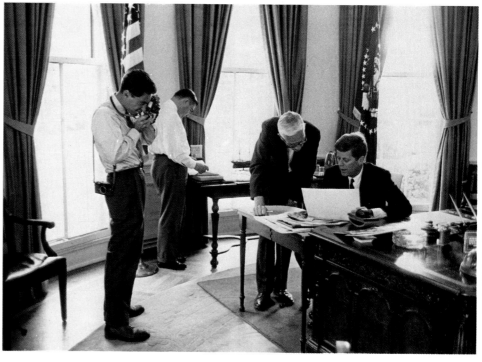

Photographing President John Kennedy at publication of the book PT 109, *illustrated by Erwitt.*

good at it, except for the time, as Elliott tells in one of his favorite stories, that "she was fired for not smiling enough."

After a few years, California alimony laws got the best of Boris and he left for New Orleans. Young Elliott picked up the lease on his father's one-story frame house at 5913 Fountain Avenue and moved in. To help get through his senior year and the next two years at Los Angeles City College, he took in boarders at $6 a week. One of these was

Elliott with his wife Diana

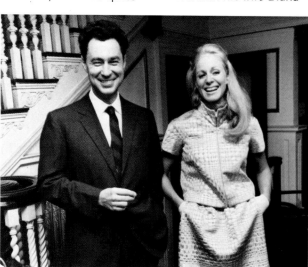

a friend he met at City College, Eugene Ostroff, who is now Curator of Photography at the Smithsonian Institution.

"Those were times when we were down to one meal a day," Ostroff recalls. "We knew somebody who owned a pet shop, and he sold horsemeat. When we were able to get enough money together we'd buy some horse fillets, get a few bottles of wine, and have a banquet." His friends and boarders were mostly teenagers who, like him, were on their own. They formed a kind of Bohemian fraternity, not without the sort of pranks that would unsettle any middle-class neighborhood. Once, when his dog had a birthday, Elliott made him a present of a pig's head and let him gnaw on it out on the front lawn.

He still recalls the Fountain Avenue days with fondness. "We were pre-beatniks," he says. "The house had a personality all its own. It was the subject of one obscure novel, and continued on after I left. It was an important place for a lot of us." Ostroff agrees. "It

was a time of learning, and searching, and groping around, not knowing which path was the correct one."

Ostroff tells a story about Erwitt's attempts to roll back one of photography's frontiers during this period of experimentation. "He was trying out new whirlpool washing techniques," said Ostroff, now one of the world's foremost authorities on early photographic procedures. "He would tie a roll of freshly developed film in the toilet bowl and flush every 10 minutes. He abruptly stopped this procedure when a roll of film got away from him."

It was about that time that Erwitt decided that photography was what he wanted to do. "It seemed like an ideal way for a person like me to make a living, because I wasn't about to get a regular job anywhere. Steady employment was to me at the time a revolting idea." Occasionally he took free-lance jobs, usually work-

ing in a drug store where he got salary and food. "That would usually last until I got caught eating more than I was supposed to." Once he worked in a photo factory that churned out fan photos of movie stars, and in one week he washed and dried 25,000 Ingrid Bergmans.

Apart from photography courses, he spent two listless years at City College ("I studied lunch") and was deprived of his diploma because he failed gym. In L.A. he met an entrepreneur looking for a cameraman to shoot a documentary in France on the fifth anniversary of the D-Day invasion, in return for boat fare. Erwitt jumped at the opportunity to return to Europe, but when he presented himself in New York he had his girlfriend in tow. The film producer reluctantly gave him two round-trip fares in an old Liberty Ship that had to be loaded outside the harbor because it was ferrying dangerous cargo. There were only six staterooms, and the passenger list included Elliott and his friend Jackie, a Haitian student, a failed smuggler, and photographer Robert Frank, who, Erwitt recalls, was not too friendly. But then, Elliott spent most of the voyage in his cabin. Later, in Paris, after the film had been shot and Jackie had returned home, he and Frank became friends and for six months shared a studio. By living cheaply and getting a few small photography jobs, he was able to spend nearly a year in France.

It was spring, 1950. He was in his 21st year and it was time to begin the serious business of a career. He returned to New York with a battered portfolio case containing 40 hand-crafted prints, some going back to the Fountain Avenue days.

"One of the people you had to see to get ahead was Edward Steichen at the Museum of Modern Art. I knew of him as an important commercial photographer from his Condé Nast days. Most photographers had not taken me very seriously, but he did. He was the first to really recognize what has become my signature. There was something rare about his sensitivity to my photographs that encouraged me in that direction.

"Steichen knew I needed a job, so he called up the Sarra studio and got me one. There I learned my great lesson, for Sarra had one of the great old-time studios. He must have been a millionaire from his photography. They did everything—food, furniture— all elaborate set-ups. His staff consisted of one-and-a-half photographers and eight salesmen, plus a whole support organiza-tion. For me, that was the great revelation about this business. It was not the production *at all,* but the implementation of production."

He lasted about two weeks. The next step was to see Robert Capa, the legendary rogue and benevolent dictator of Magnum. The celebrated war photographer gave him more names which led to a meeting with Roy Stryker, formerly of the Farm Security Administration who was then compiling a documentary photography library for Esso.

"Stryker was the first real gentleman I ever met. He did something that still touches me whenever I think of it. He immediately recognized my situation. He asked how much money I had in my pocket and I said, 'Well, I guess until tomorrow.' He then gave me a job to go to the Esso refinery in Bayway,

New Jersey, and advanced me $100 on the spot. It nearly floored me! Today, if somebody gave me $50,000 to go shoot a job, I wouldn't be one-tenth as impressed as I was then by that gracious, intelligent and perceptive act." Stryker gave Elliott small jobs from time to time, and when he quit Esso to do a documentary project on Pittsburgh for the Mellon Foundation, Elliott Erwitt went along as one of the staff photographers.

"There was always something that bothered me about Stryker, though. He always thought in terms of stories. To this day, I'm not really sure I know what a picture story is, because a story is not what a photographer does. A story is an editor's concept. I could go out and make him some nice pictures, but it was up to him to structure the story. When I did my refinery for him, he said one or two were 'wonderful pictures, but where's the story?' "

But there was something else, more fundamental, that irked him about the Stryker projects —the company's insistence on ownership of the photographer's negatives. Elliott still smarts at the thought that all his pictures from that period are locked away in some forgotten file drawer, and that he has nothing but a few copy prints. He resolved then to insist on retaining his rights there-after—an insistence that cost him many lucrative jobs, including a staff position at *Life.* In later years, as president of Magnum, he continued this fight, and at one time made up buttons inscribed "Auctoris ius Sacrosanc-tum"— "The Copyright is Sacred"—which he would gleefully pass out at story conferences with editors.

The draft that was

Erwitt during a European advertising assignment.

breathing down his neck caught up with him in Pittsburgh. In basic training he was tested and found, on the basis of his experience, to be qualified for anti-aircraft gunnery. Fortunately for the Army, that job was filled, but there was an opening in one of the alternate qualifications, that of a darkroom assistant, and Private Erwitt fell in.

He was shipped to Germany, but bribed his way into a unit stationed in France. His Army photographs were mostly of car accidents (for reports) and of generals shaking hands (for the post newspapers). He took personal pictures on the sly, and entered a collection of them in a contest sponsored by *Life* for young photographers. His essay, called "Bed and Boredom," won the $2,500 second prize. With that he purchased a Morris Minor and dubbed it "Thank You, Henry," in honor of Time-Life founder Henry Luce.

One day, while stationed in Verdun, he walked into the American Express office in the PX and met the mother of his children, the frail-looking beauty who was to become the subject of his most loving photographs, and the object of his first deeply private experience in photography.

Preserving intimate moments

Her name was Lucienne, which he shortened to Louie. She was very much a bride and very much pregnant with their first child when they moved into a small, $60-a-month apartment on Manhattan's Upper East Side in the summer of 1953. She was alone most of the day—except for the company of a docile kitten named Brutus—while Elliott stalked the offices of editors and art directors, hoping to get his career rolling again. She was anxious about starting a new life in the United States, excited about the new life growing within her. Elliott too became affected. His pictures show a compassion and love unlike any he had made before, or has made since. In making them he tapped a well of human emotion

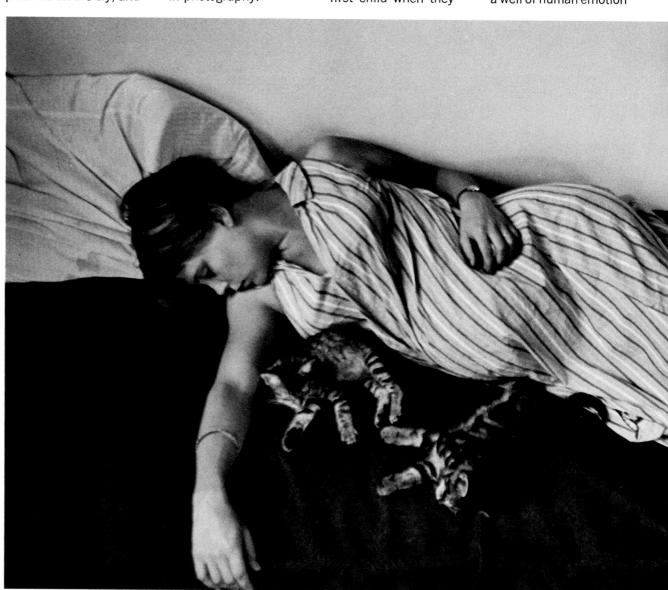

within himself that he would rarely return to.

Louie seems to relish her fertility in these photographs, and Elliott is struck by it. He photographs her with reverence, keeping some distance, perhaps out of awe and confusion over what is happening within her. He shoots with precision and economy. His contact sheets reveal a determination to achieve a pre-visioned picture, working it over and over until it clicks in his mind's eye. There is a surety when he finds it. One of the most famous pictures from this set (pages 24-25)—chosen for the Family of Man exhibit at the Museum of Modern Art—was the only frame of the situation on a roll of film with just five other snapshots. There is also a dreamily sentimental picture of Louie and Brutus eyeing each other over her rising belly. It contrasts sharply with a photograph of her distorted hands grasping that belly later wrenched with labor pains as she is wheeled into the delivery room (page 20).

When the baby appears in the arms of its mother, Louie displays a curious combination of shy pride and arrogant self-satisfaction (page 21). She radiates a sense of power that men can only envy. Elliott records the extremes of parenthood. We see Louie lying on a rumpled sheet with the late afternoon light filtering through the bedroom window (pages 4-5), her body still swollen from the rigors of birth, her breasts heavy with milk. She seems drained by the ordeal of motherhood, then a few moments later, refreshed, (pages 24-25) there is a scene of quiet adoration.

The set of pictures surrounding the birth of their first child, Ellen, are surprisingly small in number. The best of them were

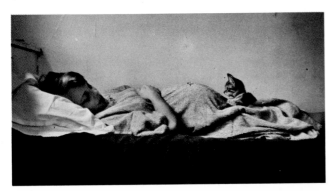

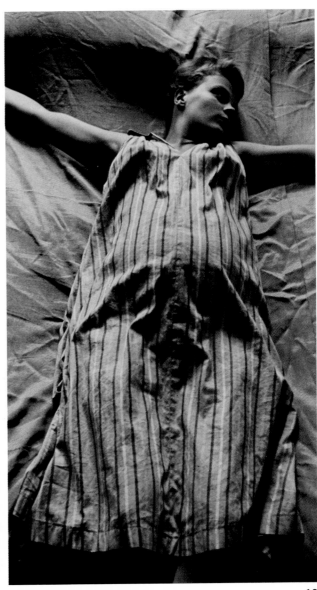

taken within a few weeks of each other. Erwitt's recollection of that time is hazy and he insists that they were nothing more than snapshots—"There was no conscious way of seeing something and trying to improve upon it." Yet his ability to convey such deep fundamental emotions with such perception suggests that the images sprang from his inner consciousness already made and that the mechanical instincts of a photographer merely fixed them on film.

It had been Lucienne's waif-like quality that attracted him to her. Growing up in Holland, Louie had been abandoned by her parents during the war and had been living by herself while employed on the U.S. Army base in Verdun. She was working in the travel office when Elliott walked up to her one day and, in his deadpan manner, asked her to book him on a round-trip excursion tour to a remote spot in India. She began charting his itinerary and remained nonplussed as he kept making changes along the route. It was some time before she finally got him to India and then, after consulting countless maps, realized that his intended destination didn't exist. She looked up to confront an "absolutely irresistible smile," as one woman calls it. He also has a way of raising his eyebrows and wrinkling his forehead when he is particularly pleased and slightly embarrassed. His expression must have tempered Louie's anger, because when he asked her for a date she accepted. Before long, they took an old farmhouse together outside of town.

"**I must say I did well,"** **he recalls with pride.** "She was a really stunning girl. There were all those officers and I was just a PFC. I always looked about 10 years younger than I was, so pictures of me at that time when I was 24 make me seem to be 12."

Although he claims the Army was one of the best jobs he ever had—and the only one he hadn't been fired from up to that time—Verdun was a depressing place to live and Lucienne brightened his remaining Army days. When he was mustered out, they decided to marry.

Robert Capa had promised his entry into Magnum when he got out of the Army. On the day of his discharge in New Jersey he drove to New York, where there was a Magnum office, and joined that exclusive fraternity of photographers. Haas was there at the time and recalls their first meeting: "He was one of the young ones who was coming around. He once showed up in Paris with a very beautiful Dutch girl. He was a quiet one . . . with a painful smile. When he told me that he had just come from the Army I took one look at him and couldn't imagine him a soldier. We spent a lot of time together. His pictures then were of Army life—the stupidity of it, the nothingness of it. I

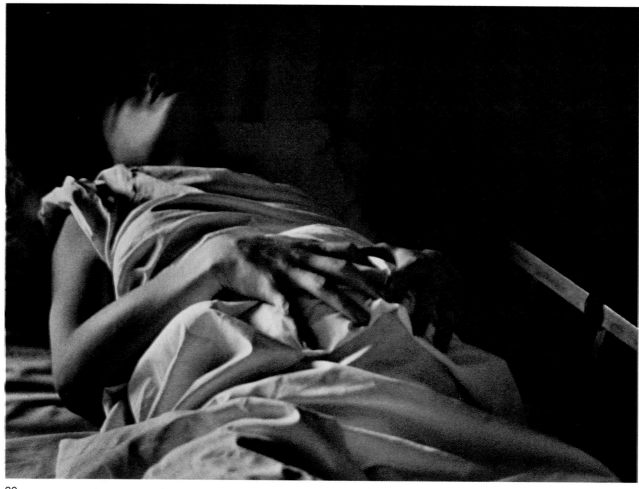

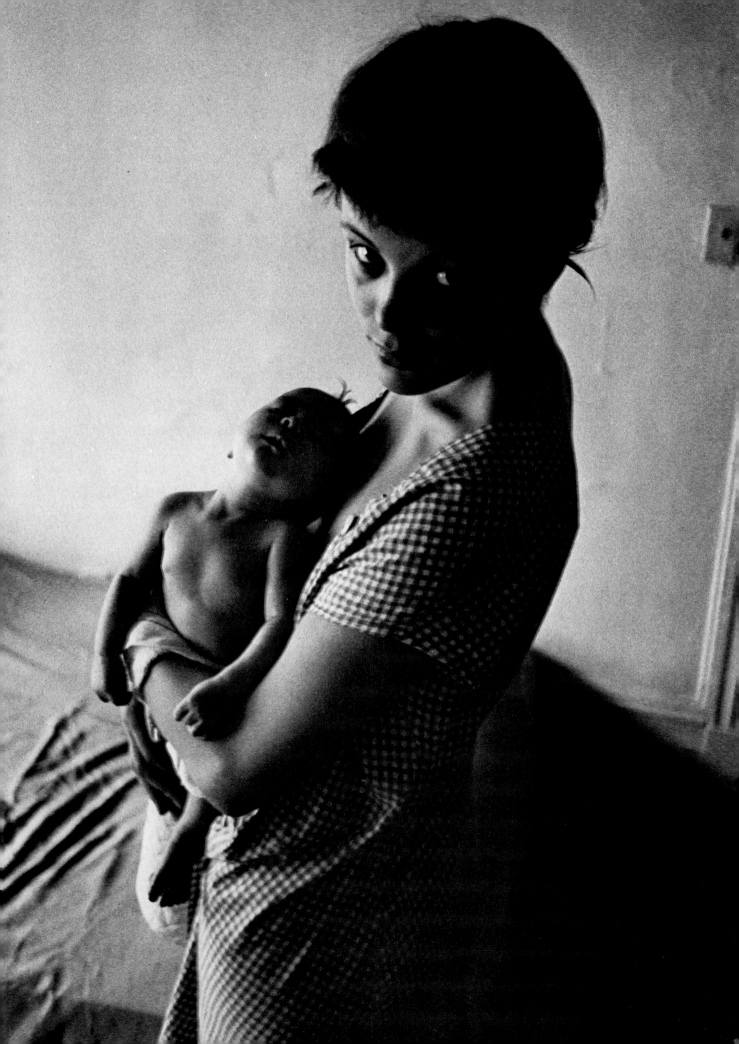

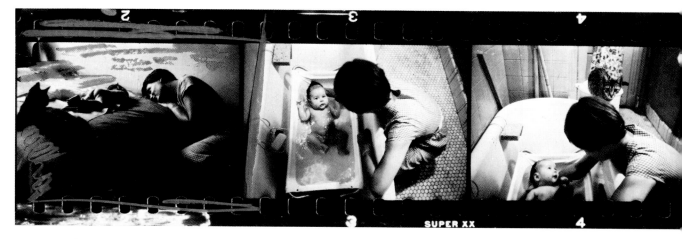

found his pictures very philosophical, definitely existential. They were about creatures fighting for their daily existence."

Elliott and Lucienne had two slight problems. He didn't have much money except his discharge allowance and the small sum from the sale of "Thank you, Henry"; and the strict immigration laws of the time prevented her easy entry into America. Elliott decided to go on ahead. Eventually it was Capt. Edward Steichen who used his Washington connections to permit Louie to be admitted via Bermuda; Magnum helped Elliott parlay an assignment there so they could get married.

Such a seemingly fortuitous set of circumstances outlined a pattern for the future management of his private and professional lives. "Even in the early days," he says, "I would decide where I wanted to go and then go out and look for a job that would take me there. When I wanted to get married, the job I needed was in Bermuda. A lot of American college students were going there then for Easter week so I suggested a story on it and Magnum sold it to Look. I got a cash advance and a trip to Bermuda, which solved the problem of where to meet Lucienne and get married." (One wag suggests that it is a

wonder he didn't name his first child "Thank you, Gardner," after Look founder Gardner Cowles.)

"My personal and professional lives are always intertwined. One accedes to the other and vice versa." Then he adds, "although sometimes this becomes a terrible problem when you have to deal with another human being."

His spiritual home for the early part of his career was Magnum—the photo agency founded in 1947 by Capa, Henri Cartier-Bresson, George Rodger and David Seymour. Basically a cooperative owned by its photographer members, Magnum was started by Capa as a

reaction against the mindless use of photographers and their craft by the publishing establishment. At its core was the then radical notion that a photographer should retain the rights to his pictures after publication. Its influence helped create the present publishing rules: editors can buy only a photographer's time, and not his negatives. Since at one time or another many of the world's premier photojournalists were members, Magnum acted like a union and its collective voice helped give professional photographers everywhere a greater control over the results of their work. Like a union, it provides per-

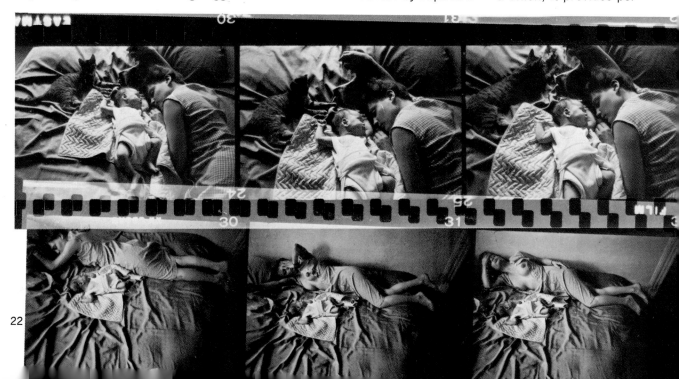

22

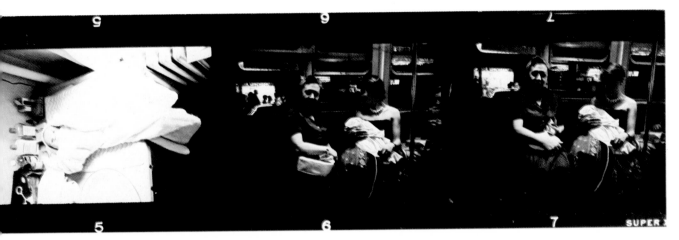

sonal benefits as well as professional ones such as the maintenance of a member's picture library and a staff to act as his agents, if desired, for a commission that is usually 40 percent. Admission is based on esthetic integrity, determined by the unanimous consent of the voting photographer members.

For some young photographers, Magnum can become a very comfortable crutch. They can eke a modest income out of the assignments that come their way, but the very name and traditions of the organization are now so august that they can provide an unwary photographer's sole stim-

ulation. Such bright young stars quickly fade out. Erwitt's star did not.

He threw himself into work, accepting everything as a challenge. The assignments quickly followed—*Collier's, Post, Holiday, Look*—only *Life* eluded him in the early days. They once called him up to shoot a picture story on the Fulton Fish

Market in New York. He would rise at two in the morning to catch the famous old market's opening and shoot it from every possible angle. When he finally handed in his prints, he got a polite thank you and a look that said, "don't call us . . ." It soon became apparent that he had been given the standard rookie's test, that *Life* had never had any intention of publishing his pictures. The revelation still rankles him. What they were testing was not his ability, but his resolve. And, was he willing to give them his negatives? He chose to take their advice and did not call them again.

Success came quickly.

The only exposures on an Erwitt roll of Super XX film. Frame 1 was blank. Frame 2 became his most famous photograph.

"I was young and fast and ambitious," he said. "I would do one story right after another. It became my policy to accept just about any kind of assignment so long as it presented me with a challenge. It didn't matter whether it was a food shot or a state visit. I wanted to take pride in the fact that I was totally versatile, and could do anything that came by. I would never refuse a job because I hadn't done that kind of thing before. I can't remember ever having blown

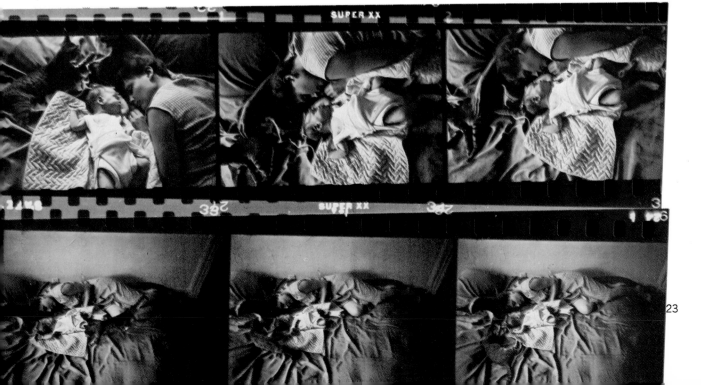

23

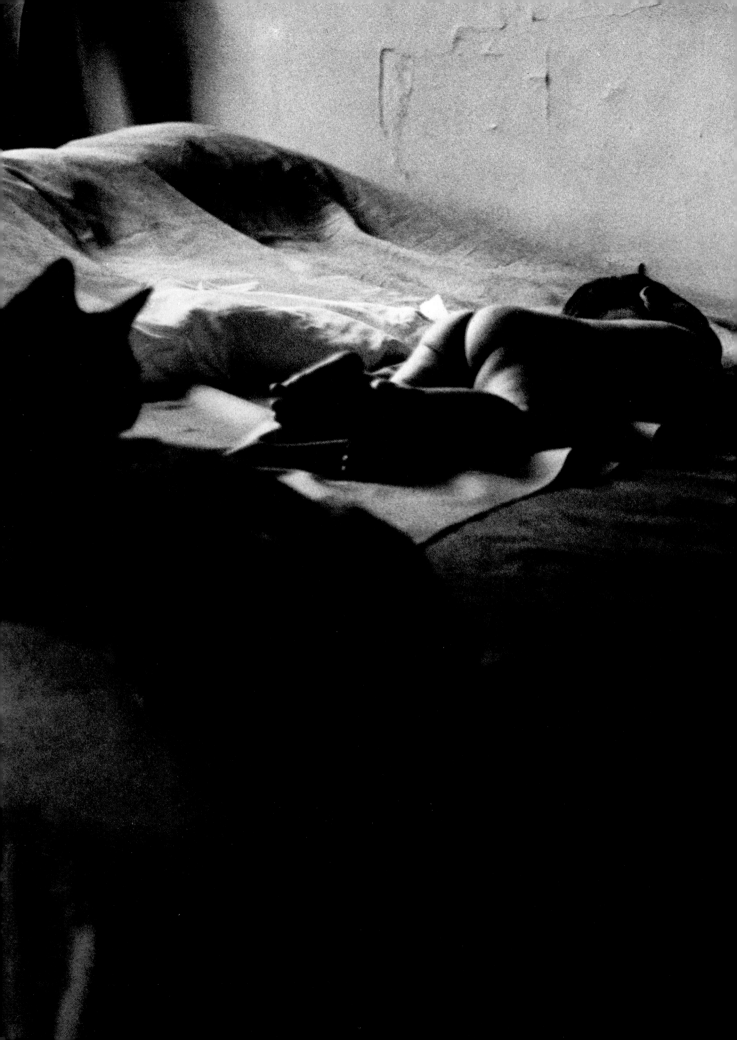

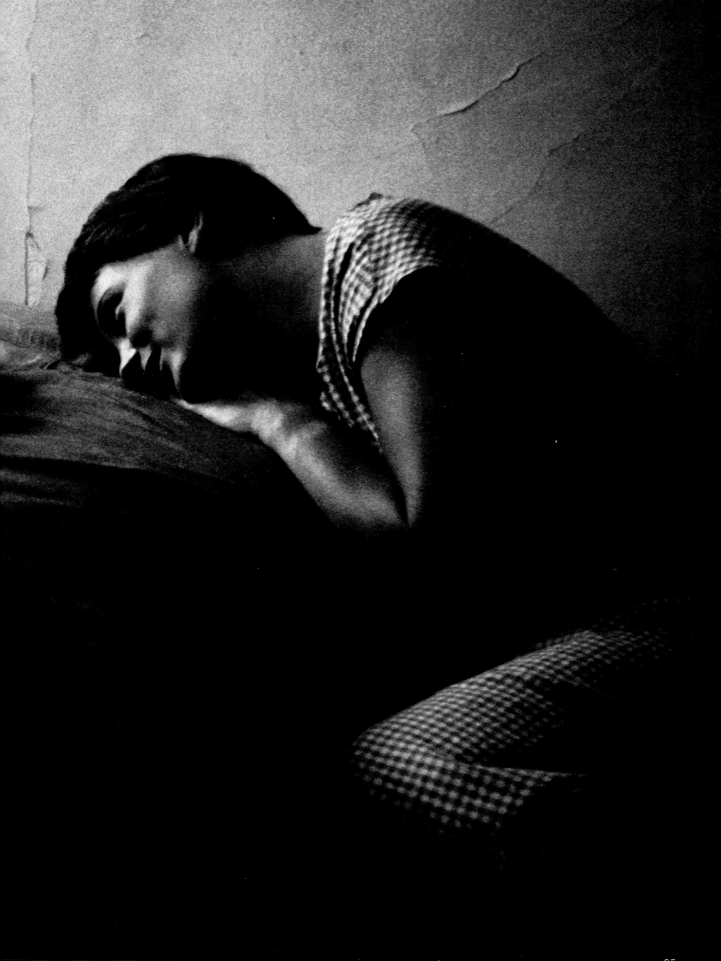

an assignment so that it was unusable because of my unfamiliarity with the subject at hand.

"I think all photographic assignments—bar none—are logical problems that have logical solutions. Technique is a myth that can be exploded by reading the literature that is available, whether it's on the Kodak box or in an instruction booklet. Photography is really very simple. You can make it more complicated by getting involved with the nuances of printing and things like that, but just making pictures is a very simple act. There are no great secrets in photography. That's why I think schools are such a bunch of crap. If you have a reasonable eye and can read instructions, you don't need that much more. You just need practice and the application of what you've learned. My absolute conviction is that if you're working reasonably well the only important thing is to keep shooting. Commercial or fine art, it doesn't matter. And it doesn't matter whether you're making money or not. Keep working, because as you go through the process of working things begin to happen. Nothing happens when you sit at home."

Erwitt points to 1954

as the date of his first major story for a national magazine. It never ran. Capa had sold *Holiday* a five-part series on children around the world. Candid picture stories were to be made by the Magnum team. For the section on the United States, Erwitt drew the Western Plains. He

rented a car and began driving through Colorado and Wyoming, stopping in windblown little towns, walking the side streets and talking to kids on the block. Driving down a back road he came across a ranch where he found what he was looking for. The boy was about 10 years old.

"In those days things were a lot less complicated. You could walk up to someone and ask them if you could make their picture. I spotted this kid, liked his looks, and hung around with him for a few days."

Elliott was welcomed by the family, which consisted mostly of the

grandparents. The boy's mother had left him, so he lived with his grandparents, and on Sundays he was visited by his father, who worked on another ranch. The boy seemed well-adjusted to the circumstances, and Elliott photographed him at school, doing his chores, and at home. He

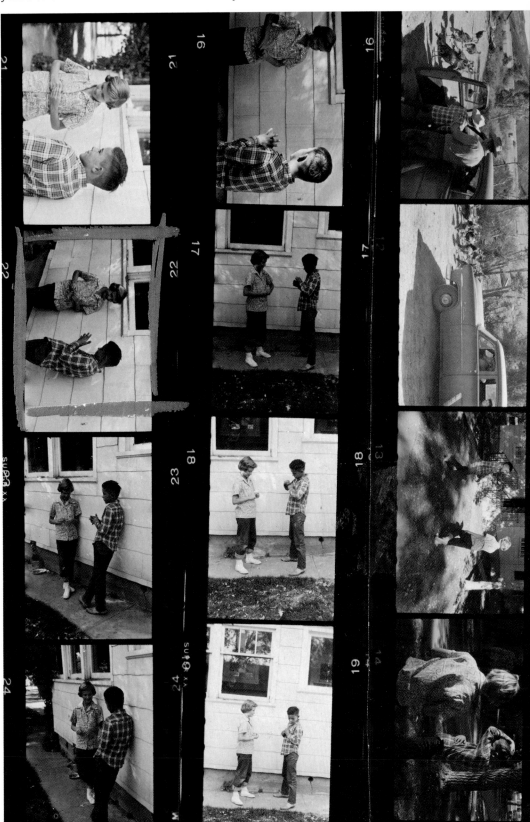

was quiet but good-natured, a bit skinny, and giving all indications of growing up to be a rangy cowboy like the generations before him. It was after the Sunday meal when his father was there that the picture was made. The afternoon light was flooding in behind the father and son, giving them a soft halo effect.

The others at the table were engaged in conversation that the father was listening to. It was "adult-talk," probably of fence-mending or of beef prices, and of no interest to the boy. He was content to be with his father again. Elliott eased off his chair and began making pictures over the grandmother's shoulder. Re-

markably, he did it without disrupting the ambiance. Then, for one brief instant, the boy slipped his small arms around his father in a simple gesture of manly intimacy. The father sensed his son's action, and although he made no outward move to acknowledge it, you can almost see tears welling up in the father's eyes.

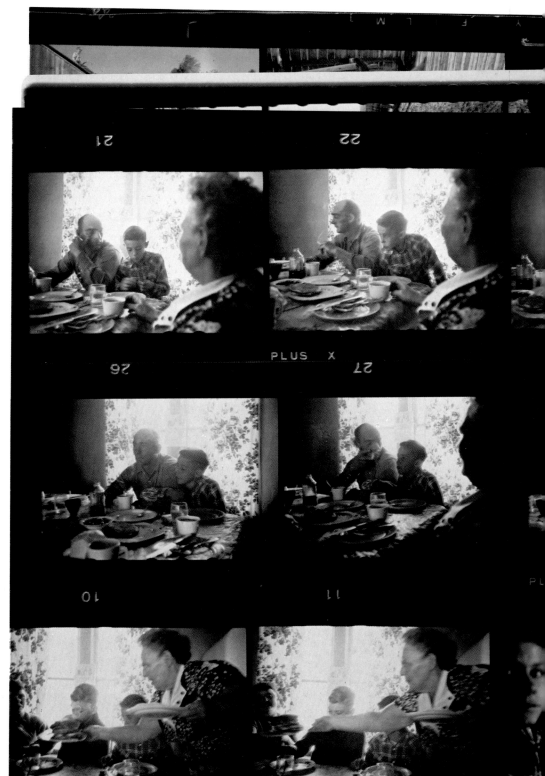

28

"It was a very touching scene, because cowboys don't show much emotion. As a story, I felt it was very successful, evocative of the true feelings of the day." Unfortunately, the editors of *Holiday* thought the boy looked too sad for what was supposed to be an upbeat story, and killed it.

"It was one of my first encounters with the kind of editorial stupidity that dictates that you should shoot the customer's preconceived notion of what the story is, rather than what is really there. I began to learn that if you went out and did just what they expected, you'd be in fairly good shape." Although he never wavered from his instinct to follow the real story, he found that he was making pictures mostly for himself. He grew to expect less from editors and more from himself. He was learning how to turn his commercial photography into his private gain. When *Holiday* sent him to Egypt in 1956 to do an essay, he traveled in style for the first time.

"It was the first really exotic trip I had ever had. I was traveling first class with all the bills paid for an entire month. It confirmed my wanderlust and further convinced me that this was the kind of life I wanted to lead. I did their story, but I also photographed all the obvious bromides—the pyra-

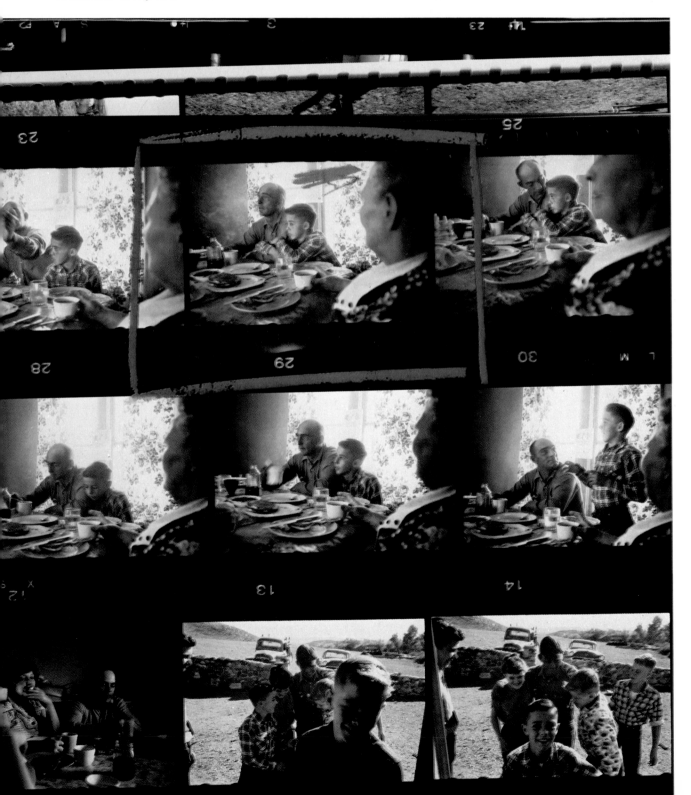

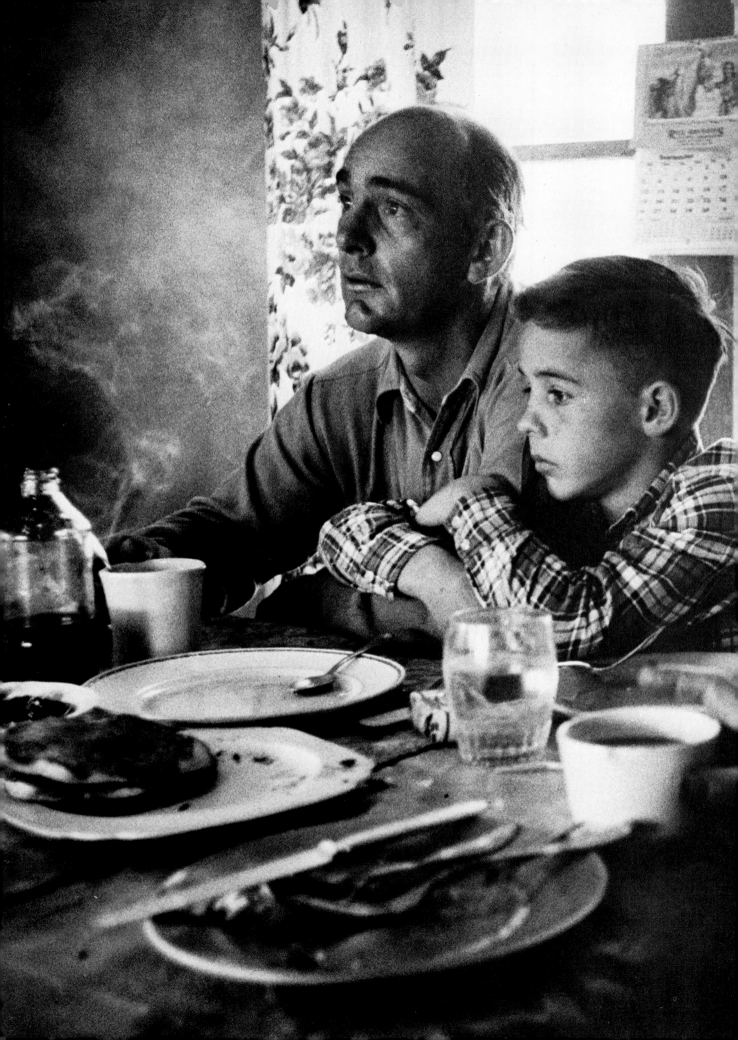

mids, the statues—and had a ball. The Egyptian government was anxious to cultivate tourism, so they opened up some tombs for me that previously had been seen only by visiting heads of state.

"Working on a situation like this requires a lot of energy and a lot of interests. You have to read the papers, overhear what's going on, and be ready to track down bits of information. You have to connect with things that may be useful to editors now and 10 years hence. The money I've made off the resale of those pictures is still coming in. A history magazine just used a pyramid picture—full color, full page, taken 18 years ago. It all adds up."

Yet some of the stories he did seemed to him to serve no practical purpose. Frank Zachary was an art director at *Holiday* who was steering a lot of restaurant stories Elliott's way. The pictures he wanted usually had to include some dignified *persona* sitting behind an elaborate table under a chandelier. Zachary had a predilection for giving people pet names. Elliott's constant reference to his pictures as "snaps" gave rise to the moniker "Snaps Pikazo." (Henri Cartier-Bresson became "Hank Carter" and Ernst Haas was "Ernie Hayes.") Elliott had a stamp made up reading "Photograph by Snaps Pikazo" and started using it on the restaurant stories as a form of silent protest.

The market for the

31

evocative black-and-white picture essay like that of the cowboy father and his son was drying up, and aside from occasional hard-news photojournalistic assignments, Elliott began to look elsewhere for work. A special irony of the aborted father-and-son essay was that the pictures were later bought by Metropolitan Life Insurance for use in an advertising print campaign. And 20 years after they were originally taken, Metropolitan Life returned again to ask Elliott to shoot two TV commercials along the same theme. What he had captured so gracefully, artfully and spontaneously from real life, Erwitt was required to stage for TV at a production cost of $163,000.

Anti-photographs

Erwitt has said that no matter how boring a job might seem, he will consider it a success if, at the end, he is able to get just one picture out of it for himself. And oftentimes he does. These personal photographs (and "anti-photographs") com-

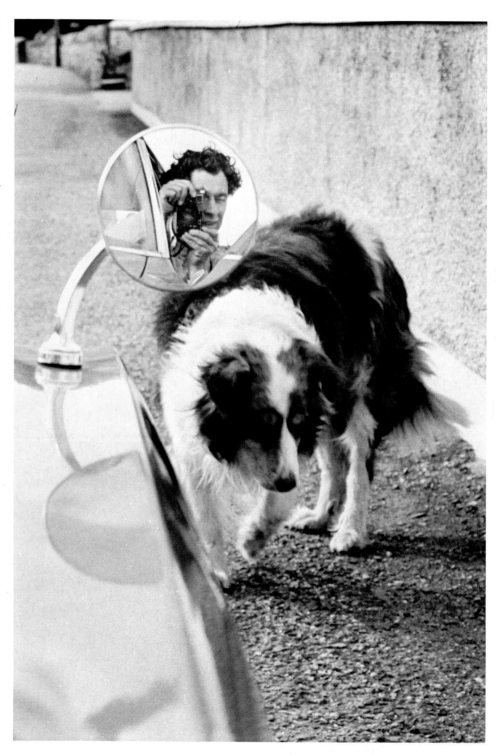

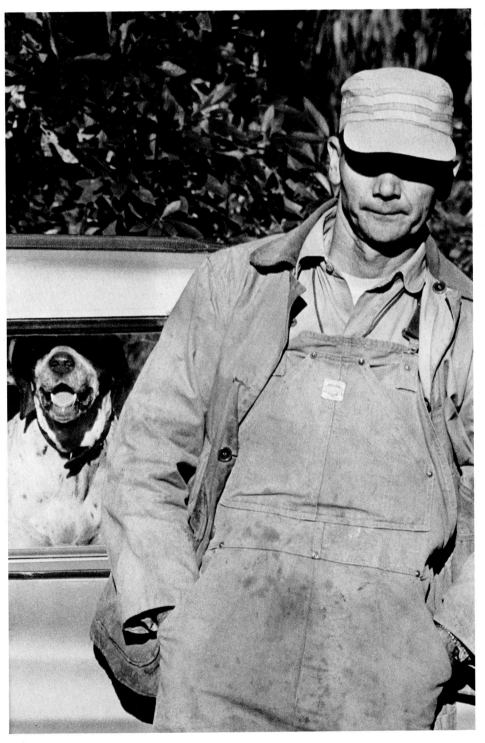

pose his signature. Yet the visitor at the party is surprised to find none in evidence about the apartment. Even the photographer has barely been seen.

He appears—this time with his hair neatly in place—to explain himself and conduct the visitor on a tour. Aside from the eclectic blend of modern art, the only traditional works are a few Modigliani prints. Stashed away in a hall bookcase are books on art, photography and Modigliani. (An inspirer of romantic legends, Amadeo Modigliani died of drink, drugs and overwork in Paris in 1920 at the age of 36. Cocteau eulogized him as "the simplest and noblest genius of that heroic age." His figures, with their elongated necks, oval faces and almost Asiatic eyes are painted with detachment and lack of sentimentality.)

When the visitor mentions certain similarities of professional—though not personal—style and points out Erwitt's own physical resemblance to a Modigliani, he laughs, his eyes squint up, and the image is confirmed.

Down a small corridor toward the kitchen, several framed photographs are crowded on a wall. Pictures by Henri Cartier-Bresson, Atget, André Kertesz. Elliott Erwitt is represented only in posters announcing past exhibitions of his work at the Museum of Modern Art, the Smithsonian, and

in galleries in England, Italy and Japan. Displaying your photographs in your own home smacks of pretense, Erwitt believes. Off the corridor, he opens the door to a darkroom. When the visitor's eyes adjust to the safe-lights he notices another figure with them at the sink. It is Erwitt's assistant, who has been printing all evening according to his instructions. A complete print-production operation has been going on all during the party, which explains the host's occasional disappearing acts.

Erwitt inspects some prints in the wash tray, leaves others to be reprinted, and then proceeds to a spare bathroom in the back of the apartment that has been

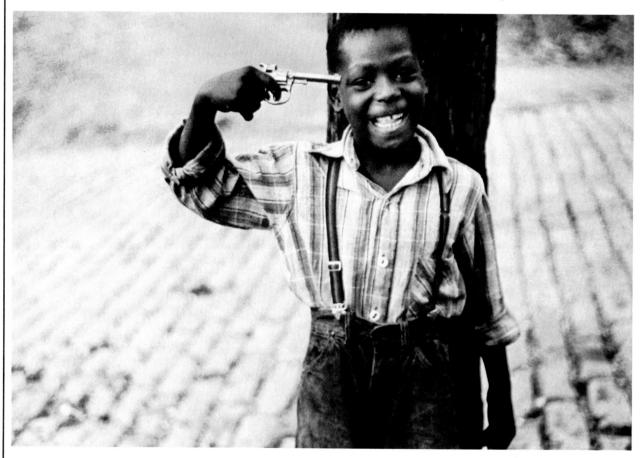

turned into an archival washing facility. The room looks like the secret laboratory of a mad alchemist. Plexiglass tanks are bubbling over. Prints are stretched out to dry on hygienic screens. The operation Erwitt is experimenting with is designed to get all the chemicals out of the finished print. If people are nice enough to pay $150 for one of his prints, Erwitt reasons, then it should last as long as possible. Yet with all the time spent on this procedure—each group of prints goes through a finishing cycle totaling 5 hours—he is not making much money on them.

He pulls out one of his all-time favorite pictures. It is one of his underdogs. This one, with only its paws emerging from

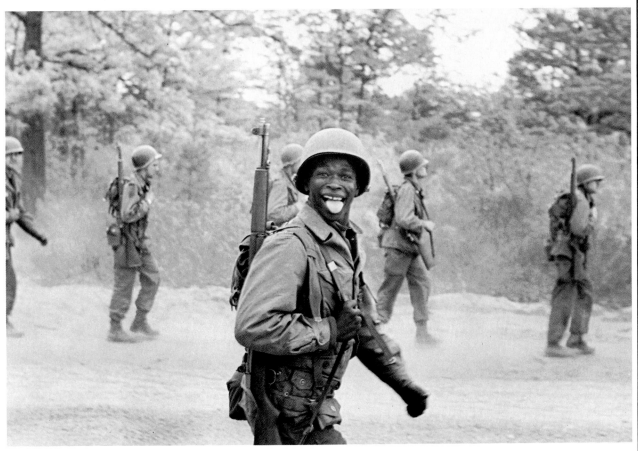

under a coffee table, and its owner's feet nearby, was literally right under his nose. He discovered it in Holland when shooting Crown-Zellerbach employees in their homes for the company's annual report. Another favorite is of a pitiful little dog with a disabled hind leg staring down a line of cars in Rome. "The dog's only natural enemy is the car," says Erwitt. "Dogs don't usually die a natural death. They get run over. When you see a dog get all excited about riding inside an automobile, he is happy because he knows it's unlikely that he'll be run over by it."

Humorist P. G. Wodehouse finds these dog photographs "superb." Writing in Erwitt's book, *Son of Bitch,* he finds

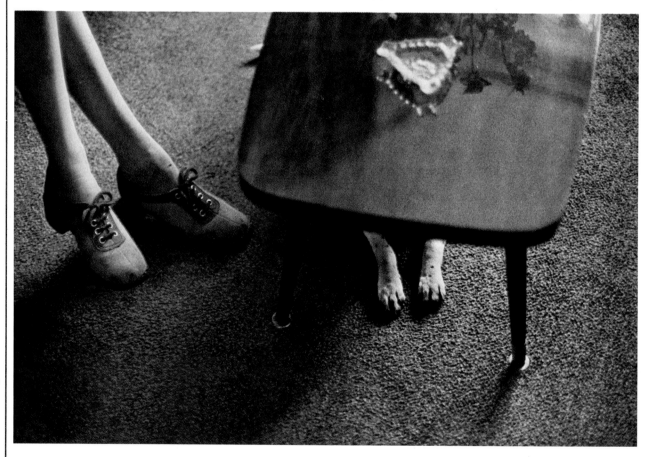

them warm and sympathetic. "It does one good to look at them. There is not a sitter in his [Erwitt's] gallery who does not melt the heart. And no beastly class distinctions, either. Thoroughbreds and mutts, they are all here."

His friend Ernst Haas sees the dog pictures in another light, as a vehicle for venting a macabre humor. "He has a special feeling for the—what they say in German, the *krea-tur*—of those lowly, downtrodden individuals who persist in the face of great adversity. To photograph this in humans sometimes degrades them. But Elliott does this with animals in such a way that everybody recognizes the human qualities there, and it becomes much more delicate."

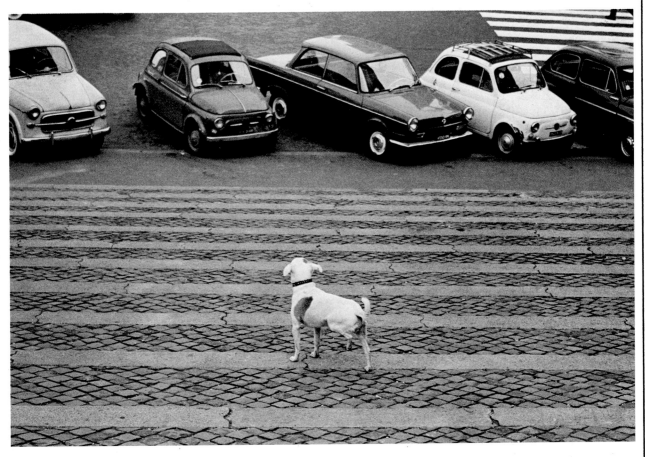

Another friend suggests that at the root of his humor there must lie a tremendous bitterness. "There's a starkness to them, a tremendous reality that at times points to the futility and absurdity of life. It doesn't seem to be a loving, but more of a ludicrous look at us The body of his work is from the point of view of a person who thinks we are a pretty ridiculous bunch, and it doesn't seem to have the love that you should view our plight with."

Witness a picture made in Mexico, where two students have paused to chat, seemingly oblivious of the petrified corpses lining the corridor. (Page 45). The soil in that region mummifies bodies, so the enterprising proprietor of a cemetery dug them up to put them on display as a tourist attraction.

Erwitt's constant discovery of ironic juxtapositions in the real world is at times wry and whimsical. Once he made a picture of a snowy egret miming the inelegant construction of a water pipe at a Florida beach. Working along the beach-

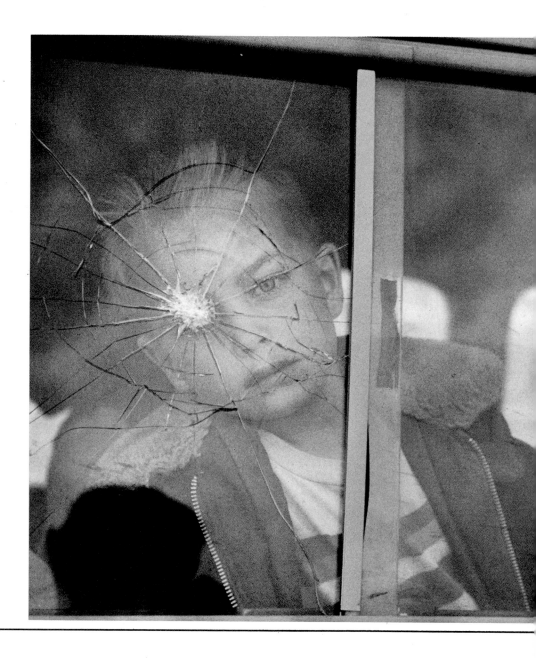

front is a constant challenge to him; he contemplates his next book of photographs as consisting of just those made at the shore. As a possible sequel to the dog book, it has been suggested that he call it *Son of Beach*.

"Somehow the attitudes people have about themselves are manifested more at the beach than elsewhere," he says. "You have to really present yourself at the beach. Because you have to appear almost naked, you tend to exaggerate, particularly if you're a girl. Girls go there to be seen. All their traditional elements of trickery are reduced to a small bathing suit. For the photographer, it's great. The backgrounds are plain; it's as close as you can get in nature to the kind of seamless paper you use in a studio. The scale is wonderful, and there is so much space you can move around in. You can relate disparate elements easily. All in all, people do things that are more amusing than usual."

Erwitt himself is not immune to his theories about human behavior at the beach. Diana Erwitt

regards him as "religiously unathletic," perhaps because she has seen times when the sight of someone tossing a football on the beach has made him immediately pick up his towel and head for home.

But at other times, his juxtapositions are frightening. There is his picture of a near manic-looking child with his eye lined up behind a spider-webbed window. (Pages 40-41.) It could be a fatal frame stolen from some high-speed camera recording that horrible half-moment between the firing of a gun and the victim's realization that he has been shot. But it isn't. "It's just a kid I saw in a school bus in Colorado. Essentially the picture was there,

and I moved very little in order to strengthen the juxtaposition."

Erwitt's pictures on occasion exhibit a pronounced existential strain. His subjects have a fatal-istic acceptance of their circumstance, but also a resolve to plod ahead. They are the centers of their own worlds, initiators of their own hapless actions, and seem uncon-cerned with the inevitable consequences.

Writing in the book *Photographs and Anti-Photographs,* John Szar-kowski says, "His sub-jects seem to be the patient victims of un-specified misunderstand-ings, waiting the prompt-er's cue on a stage designed for a different play. Over their inactivity hangs the premonition of

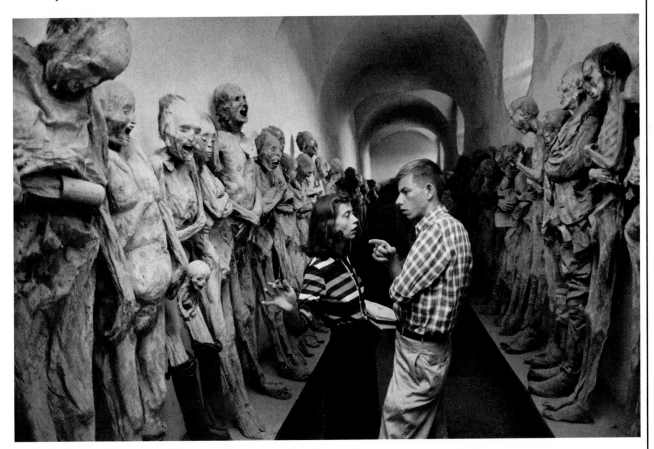

a pratfall. From these unmemorable occasions Erwitt has distilled, with wit and clarity and grace, the indecisive moment."

When questioned on the existential implications in his work, Erwitt scoffs. "That all got started when a *Life* editor used some of my pictures to illustrate an article on existentialism. I consider that nothing more than a nice sale from my stock library If it's true, it's nothing that is done consciously. It's just there."

One of the earliest pictures in that vein occurred during Erwitt's period with Stryker in Pittsburgh, compiling the documentary for the Mellon Foundation. "In those days I was really eager," he recalls. "I walked the streets day

and night making pictures. All the juices were flowing and my life was uncomplicated. One day I came across some black kids playing cowboy. That was a long time ago.

There is an obvious symbolism there, but back then it wasn't so obvious.

"I always made it a point to carry a camera with me at all times in those years. A little later, when I was in basic training, we were on maneuvers and one of the black soldiers going by looked at me and laughed, and I took his picture."

He continually points out to critics that these pictures are just snapshots, grabbed on the sly between commercial assignments all over the world. Sometimes they even go unnoticed by him.

"I just shoot at what interests me at that moment. Sometimes I don't go through those contacts for years. Then, when I have nothing better to do, they fall under my eyeballs and I see a good picture there. I recently discovered something quite nice that I shot in 1966, and I saw it for the first time two weeks ago."

Nevertheless, these pictures are no accident. During one of former New York Governor Nelson Rockefeller's re-election campaigns, Erwitt watched a sidewalk debate in Albany. His uncanny foresight and eye for irony made him focus on one of Rockefeller's littlest constituents. After some minutes of listening patiently to his master's voice, the hound tired of doggerel and registered his opinion on a nearby post.

Henri Cartier-Bresson, a founding father of Magnum, still exerts a commanding influence in the organization although he is not as active in it as he once was. Of all the prodigies that have passed through Magnum, Cartier-Bresson expresses a special pride in Erwitt for not having dropped the torch.

"Elliott has to my mind achieved a miracle," he says, "working on a chaingang of commercial campaigns, and still offering a bouquet of stolen photos with a flavor, a smile from his deeper self."

Photo-journalism

All societies have to have strata, and photographers seem to have elevated the photojournalist to the highest level of theirs. It is a specialty within the profession that requires all the elements of the other kinds of photography: creativity, style, elegance, wit and craft. Photojournalism adds a few of its own: courage, stamina, cunning and luck.

Elliott Erwitt is a photojournalist. He seldom uses the term in describing himself, but evinces a quiet pride when it is applied to him. Perhaps because he does so little of it these days, he doesn't let it drop in his conversation. It might sound pretentious, and Erwitt loathes pretense of any kind. Once he dismissed the work of a celebrated *Life* photojournalist to a critic as being "pretentious." When the critic asked him to elaborate, Elliott pointed to the photographer's overly-manicured mustache. The critic let Erwitt's quixotic remark pass, but later said that upon re-examination of the photographer's work he had reached the conclusion that it was "overly-manicured."

The aura of the photojournalist has been, by and large, built up by photojournalists themselves. When John K. Jessup retired after years of writing the unsigned editorials for *Life,* he addressed a distinguished congregation of his peers from *Time, Life, Fortune,* the New York *Times,* and numerous other publications. They had come to pay tribute to a man whose weekly editorials spoke for the Time Inc. empire and had reached an audience of millions, although only a handful of readers knew him by name. When he spoke, it was not about the great issues of the past, or of his predictions for the future—the kind of high-minded rubric usually found in farewell speeches. He spoke of what had interested him most during those years—the company he'd kept. "More than any other profession," Jessup said, "be it doctors or lawyers, politicians or electricians, journalists like nothing better than the company of other journalists—particularly if they are with better journalists than they are."

This dynamic camaraderie among journalists extends to those who carry a camera. The interaction among its membership is the very cement that holds Magnum together.

When Erwitt returned to New York after having spent the spring and

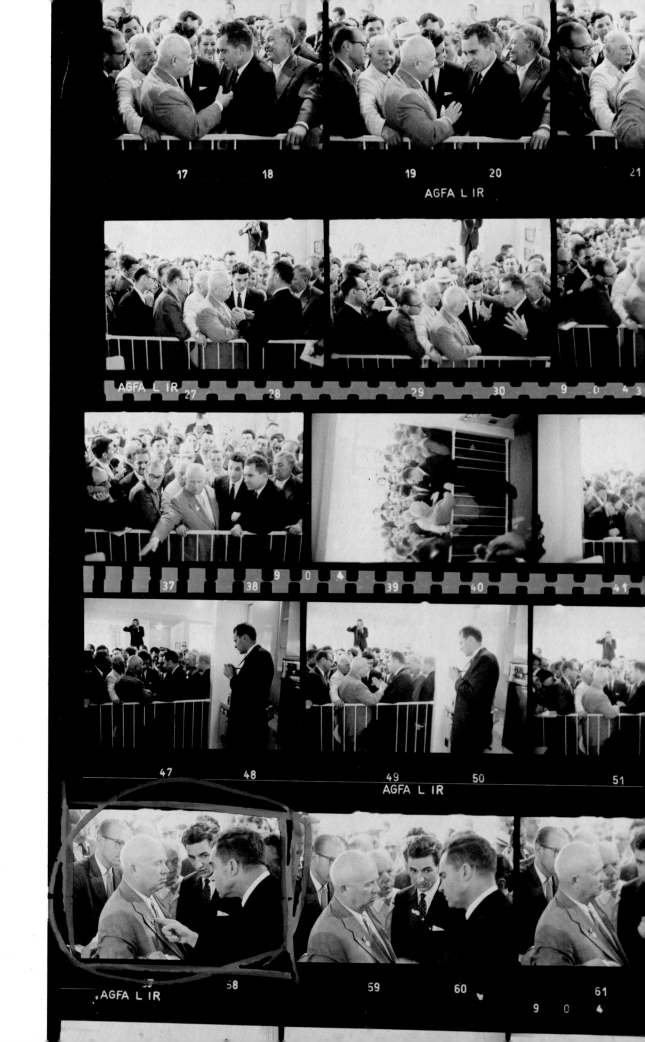

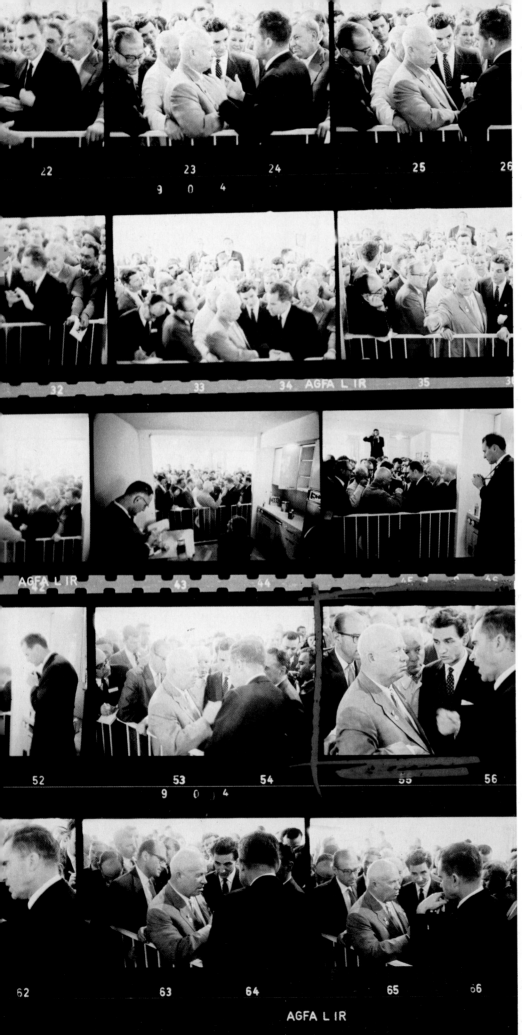

early summer in Europe on advertising assignments, the first thing he did was hop the shuttle to Washington to catch some of the Watergate hearings—live.

"I'm still accredited for the Senate, so I took the opportunity to hear the Mitchell testimony firsthand. I had missed all that, and wanted to smell it a bit. It was marvelous stuff. There were all my old pals, or what's left of them. I just love the atmosphere of journalists, and then having the ability to sit 25 feet from that creep Mitchell and look into his eyes—to perhaps even ask him a question—and have a personal reaction to a historical moment is really quite pleasant."

Journalists of all stripe like to get together to tell stories, and the stories behind the stories. Herewith are three Elliott Erwitt stories.

Story #1: The famous Kitchen Debate picture evolved out of an assignment whereby Westinghouse had sent him to cover a U.S. industrial exhibit in Moscow, in the summer of 1959. Erwitt was asked to get pictures of Russians looking at our consumer goods, but when Richard Nixon arrived at the fair Erwitt attached himself to the Vice-Presidential party and was present during the "historic" Kitchen Debate with Khrushchev. It was staged in front of a model kitchen assembled by Macy's department store. As the debate heated up, and the pho-

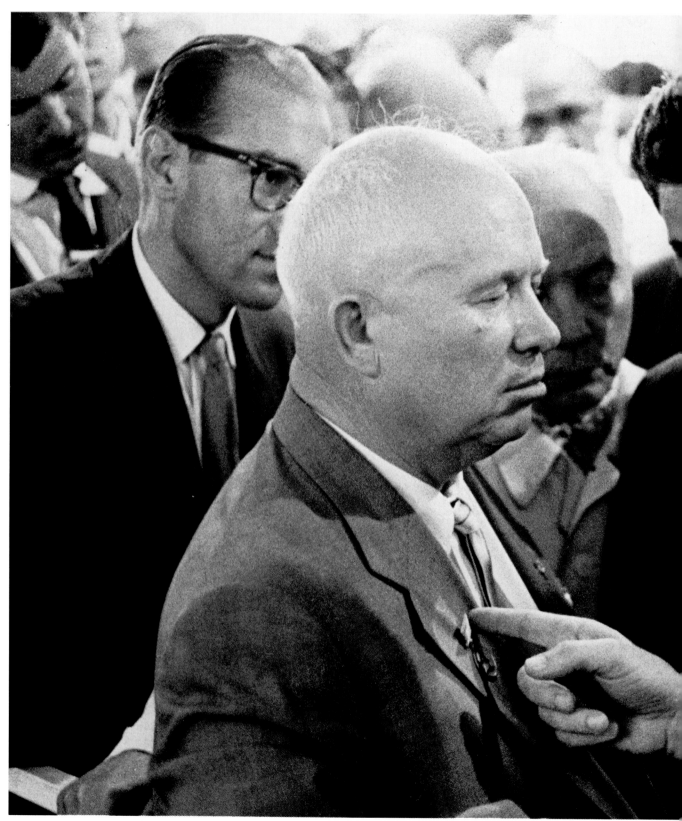

tographers crowded around, Erwitt slipped out of the press melée and attempted to get inside the kitchen. Macy's public relations man at the exhibit was William Safire, later to be a speechwriter for President Nixon and even later a conservative columnist for the New York *Times.* Safire let Erwitt inside the exhibit so he could obtain a different perspective. It soon became apparent that Nixon was grandstanding for the press.

"It was ridiculous," Erwitt recalls. "Nixon was saying, 'We're richer than you are' and Khrushchev would say 'We are catching up and we will surpass you.' That was the level of the debate. At one point Nixon was getting so irritating that I thought I heard Khrushchev say (in Russian) 'Go fuck my grandmother.' I quickly looked up to see if anybody else had got it, and caught the eye of Harrison Salisbury of the *Times* —one of the few Westerners there who spoke Russian. He got it.

"I think I can say with reasonable accuracy that I'm in some way helpful for Safire's career. He was nice to me, letting me into the kitchen. As a courtesy, I sent him an 8x10 print of this picture. The next thing I know, Nixon's running for president and this is the campaign poster. They must have made a million copies of it. There were even murals—all made from that damn 8x10. I think it was the most widely known campaign photograph ever.

"I never gave my permission to use it, but it was too late by then. So I

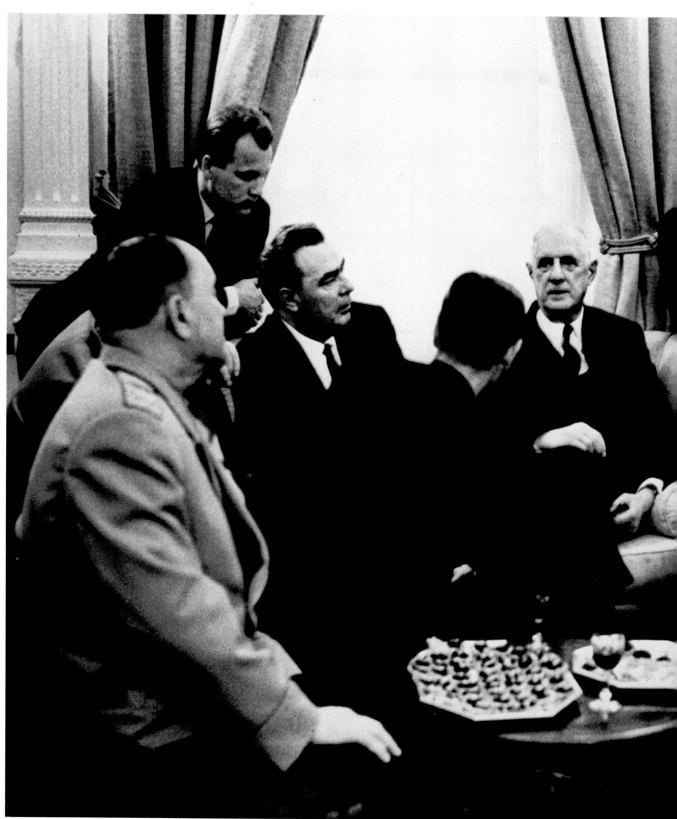

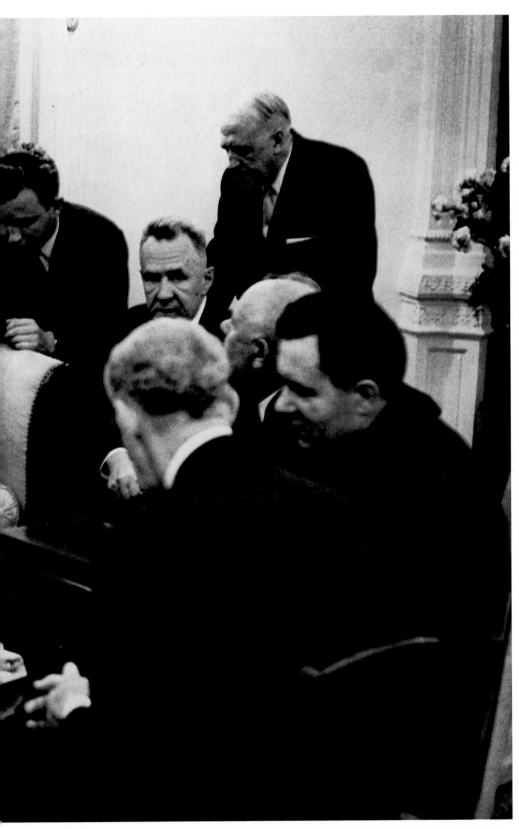

sent them a bill for $500, which they paid. Nixon had his people make up a list of all those who were present during the Kitchen Debate and I was added to the list. He sent us certificates, like the ones Pan Am gives you when you cross the equator, that made us members of the Kitchen Cabinet. I was for Kennedy in that campaign, but still, several of my friends were upset with me for allowing them to use my picture like that.

Story #2: "I've been very lucky in Russia; I brought out the first pictures of the Soviet missiles. I happened to be there for *Holiday* magazine when Sputnik went up. I read it in the papers like everyone else. I knew that a planetarium would be a good place to make pictures, and sure enough, there was somebody there lecturing with a model satellite. That became the cover for the New York *Times* magazine. I saturated the event and really cleaned up. They even held the presses at *Life* for my last set of pictures.

"The satellite was launched on the occasion of the fortieth anni-

President de Gaulle of France and various Russian leaders, photographed quietly in natural light.

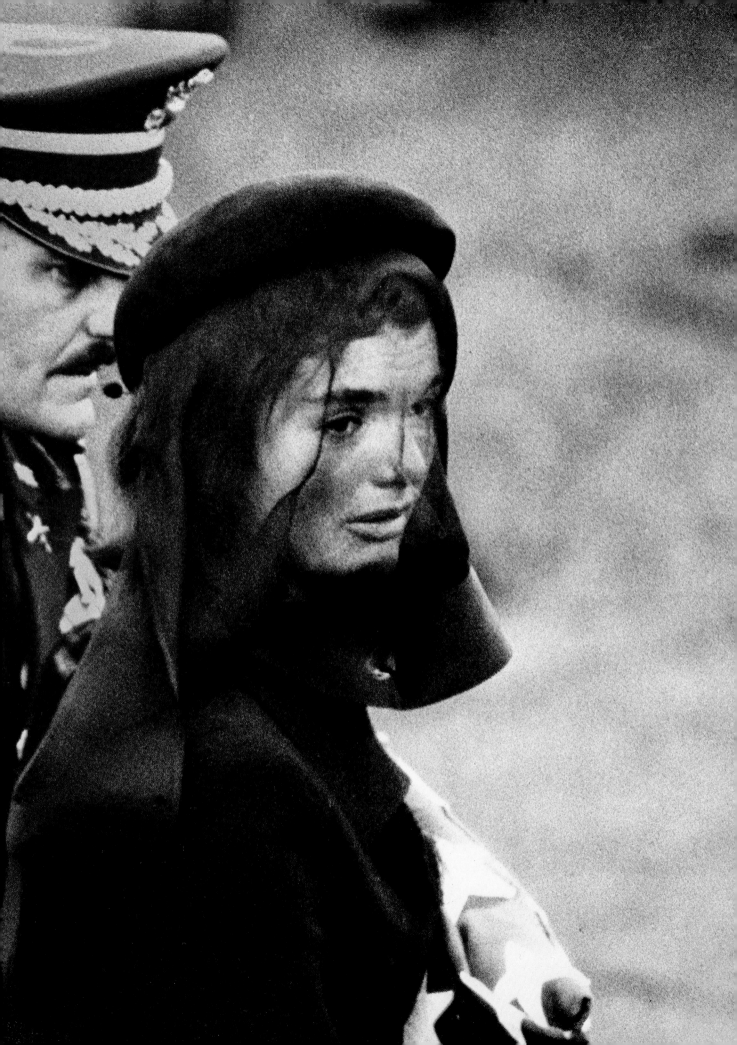

versary of the revolution, and on November 7 there was a big parade. Foreigners were prohibited from having cameras. I had a pass to see the parade, but didn't go where I was supposed to. Instead I attached myself to a Soviet TV crew and walked with them through five security lines. Incredibly, they set up right in front of Lenin's tomb. I unpacked my cameras too. Although I was questioned by a guard, I was able to convince them that I belonged there. The parade is one of incredible precision, most impressive. The military part of it goes by at breakneck speed. In 10 minutes, examples of the entire Soviet arsenal pass through. I shot three or four quick rolls and then raced to my hotel room a few blocks away, where I processed it in the bathroom. Unexposed film is suspicious-looking and I didn't want to risk them X-raying it. Besides, negatives are easier to hide. I caught the first plane out to Copenhagen, where I was met at the airport by *Life*. There was a congratulatory phone call from managing editor Ed Thompson in New York. It was the biggest thrill of my life. I was a hero Other magazines even ran a picture of me!"

Story #3: "I fell into photojournalism. I don't remember precisely my first story, but I imagine I tackled it logically. You're there with a bunch of other guys, so you just follow the crowd until you get the feel for the story. I developed a technique that was very successful for me. After following the crowd for a while, I'd then go 180 degrees in the exact opposite direction. It always worked for me, but then again, I'm very lucky.

"An excellent example is a picture of de Gaulle with the Soviets (pages 54-55). Considering the circumstances, it's insane that I even got the picture."

In 1966, de Gaulle was making his bid for French sovereignty by showing his independence from the NATO allies with a state visit to Russia. There was concern in the U.S. that *le grand Charles* was making a private deal that would upset the balance of power between East and West. A press conference was held at the French Embassy in Moscow with dozens of photographers clambering all over each other.

"I had taken my picture of de Gaulle shaking hands with the Russians. What else can you do? I got bored, so I went home. Back at the hotel I started feeling guilty about leaving my post too soon. I was really tired, but on a hunch I decided to get my ass back there. When I got there all the other photographers had gotten bored and left too. The place was deserted. I went inside and started wandering through the rooms. I stumbled into a huge meeting room, and there they all were—Brezhnev, Kosygin, and all the other Russian statesmen—surrounding de Gaulle. I stood casually by the wall for a while and made a few quiet pictures. I checked my lighting. It was very low, a quarter of a second at f/1.4 with a fast color film. They didn't question my presence because I acted natural. I wasn't imposing my presence on anyone, either, which is very important for a would-be photojournalist to remember. I stayed back. The average photographer would get right in there as close as he could and

be bounced in an instant. That's just not necessary. The most irritating thing about covering news is the way photographers keep creeping up on their subjects, anxious to get just a little more, and then a little more. What's the sense? Everybody has long lenses. If you keep your cool, you'll get everything." The picture of de Gaulle with the Soviets was a scoop. *Paris-Match* magazine reprinted their regular cover with the photo holding up publication two days.

By not invading the propriety of the moment, Erwitt made one of the most eloquent photographs of the Kennedy era—the grieving widow at graveside. He stood on a small hill behind the site and trained his 600mm lens on the face of Jacqueline Kennedy. The printed picture is less than half the original frame, making the image the equivalent of a 1500mm perspective and heightening the grainy, sad effect.

"I'm not very good at pushing. I went to that celebrated birthday party for the Shah of Iran where I saw a lot of that kind of pushing. The best pusher in the business, in my opinion, is a Magnum guy, Bruno Barbey. He's a very sweet guy, but when he's working, get out of his way or he'll trample you. He's incredible. I'm so envious of his ability. There was not one line throughout the celebration that he was not at

the head of—not one! He never offends anyone, but always manages to get in front of them. I call him 'The Velvet Glove.' "

Diana Erwitt echoes Jessup's statement about journalists, and tells a story of her own. "Photographers are never boring. Gather four photojournalists in one room and you'll have enough energy to light the city. The better they are, the more energy they exude. They come alive when someone interesting comes along, but they don't suffer fools very well.

"I never expected to find such total, absolute dedication to the work. The glamor never wears off. There's nothing more glamorous than being with them at a place where something important is happening. It's hard work—I don't envy Elliott that. I mind that fact that the home life isn't as important, ever.

"I should have recognized something when we were on our honeymoon in Iran. We had been married two weeks. We were leaving Teheran and Elliott was trying to decide whether to ship the film separately or to take it with us. He thought that there would be too much trouble with customs unless we were there to explain it, so we carried it with us. In the air, we ran into a terrible thunderstorm. Lightning was dancing up and down the wing, the nuns across the aisle were crying while saying their rosary, and the cabin was being buffeted about. I have never known such cold terror. The lights went out. My fingers dug into the armrests. I looked over at Elliott. He had just reached for a cigar and was calmly biting the end off it. He said, 'I knew I should have sent the film.' "

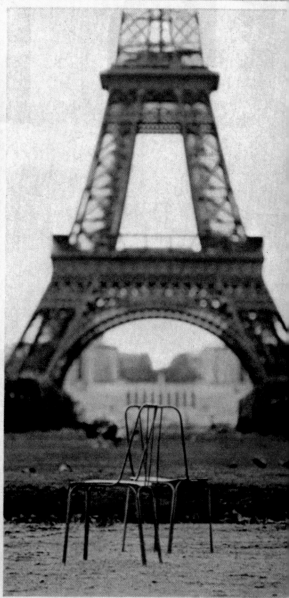

Next time you go to Paris,

Your first time in Paris—as you scooted by in your taxi or sightseeing bus—did you notice all the chairs? Did you wonder who has the time to sit on them? The Parisians do. And the connoisseurs among the tourists. Sure, you can see Paris from a bus. But you can best taste, feel, live and *think* Paris from one of those chairs.

A chair in a Paris park costs you 3¢ for the chair-lady. A chair in a neighborhood Paris café costs you 5¢ for a cup of coffee. From then on, you can have the time of your life without walking another step, or spending another centime.

Whatever you came to Paris to experience—there's a chair to experience it from. For the Eiffel Tower, a chair on the Champ-de-Mars. For ardent young lovers, a chair in the Luxembourg Gardens. For charming (and cultural!) statues, a

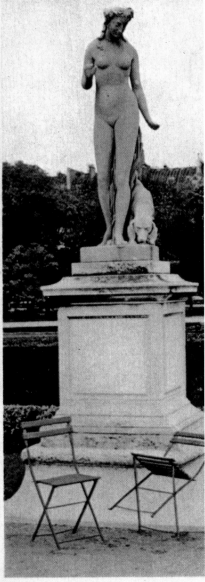

sit down and enjoy it.

chair in the Tuileries. For bearded artists, a chair on the Place du Tertre. For supremely elegant women, a chair on the Champs-Elysées. For Left-Bank intellectuals, a chair on the Boul' Mich.

Perhaps you've come for that extraordinary "vin ordinaire," or a crusty croissant...take a straw chair in any sidewalk café. Perhaps you've come to buy luscious leather gloves or a glittery evening bag...take a carved rococo chair in any fine shop.

If you're willing to spend a bit more, there are the gilt period chairs at Maxim's...the red velvet chairs at the Opera. And if you want to spend nothing at all, there are the free park benches. (A shrewd way to meet the Parisians.)

When it's time for your next vacation, and all you want to do is "collapse on a chair somewhere"—why not take a Sitting Tour of Paris!

For folders, maps, and other information on Paris, write: Dept. T-4, Box 221, New York 10. French Government Tourist Office: New York, Chicago, San Francisco, Beverly Hills, Miami, Montreal.

Advertising: Paying attention to detail

Elliott Erwitt's most lucrative editorial account became *Holiday* magazine, but some time during the mid-1950s Erwitt began to notice an increasing demand for the "chandelier shot." Whether the story was in Egypt or Holland, he always had to produce a set-up of a local personality sitting in the best restaurant with an elaborate feast before him and a gaudy chandelier above. Slowly the line between advertising and editorial became blurred.

"I figured that if I was doing what amounted to advertising I might as well get paid advertising rates, so I eased out of editorial and took up advertising with a vengeance."

The reaction back at Magnum was: "Blasphemy!" To many it was a corruption of all of Capa's ideals. Gradually, however, the others began to dabble in advertising, and the decision to expand into commercial photography held the co-operative together during the lean years of the Sixties when the big picture magazines began to fold.

Erwitt would always structure his jobs to allow for a few days off when he would make his own personal pictures. "The kinds of advertising jobs I look for take me all over the world. To me that's essential, to get away from New York, to replenish myself and find some time to make my own pictures.

"It was quite a change. You can't tackle advertising as you do journalism. The attitudes are completely different. With journalism the problem is dealing with what's there and not tampering with it. The problem with advertising is finding the approach. By its very nature advertising is a con, but you have wide latitudes. Pablo Casals returning to Puerto Rico isn't a story for a magazine without Casals and his cello. But in advertising you can fake it. You don't have to have *his* cello—you don't even have to have Casals." (Page 1.)

Erwitt's first major advertising campaign, commissioned by the Ogilvy and Mather Agency, was for the Commonwealth of Puerto Rico. The first ad in the series was based on the cellist's making the Commonwealth his home and Casals had just had a heart attack. Erwitt improvised with pictures that agency president David Ogilvy calls "pure genius."

He arrived at the hacienda of Casals' mother and discovered an elegant room where the maestro had once played. A graceful fan light above the balcony portal mirrored the shape of a borrowed cello which he set up in front. To break up these stylized symbols he inserted a chair whose curved headrest modified both, easing the transition and breaking up the open space. The agency was so pleased that they accorded the photographer a rare tribute, placing his credit at the end of the ad copy.

The success of Erwitt's travel campaign opened the doors to other agencies, and Doyle Dane Bernbach hired him to shoot pictures for the French Tourist Office. Every spring for the next six years he could count on spending two to three weeks in France with a $5,000 guarantee. His photographs were made into anywhere from five to seven different ads from which he could expect to receive $1,500 for each one that was used.

Agency president Bill Bernbach went along on the first trip and noticed Erwitt's journalistic instinct to flow with and adapt to a story, even though he was just shooting an ad.

"While we were on location in the South of France," Bernbach recalls, "I noticed how often people went by carrying a loaf of bread. We decided to make up an ad on the spot. Our driver, who was also serving as Elliott's assistant, became the model. We went and got his nephew and put them on a bicycle and shot it that day. Elliott was able to grasp the idea quickly and turn it into a documentary photograph. This was tremendously important to us because the whole success of the campaign rested on the believability of the photographs. We were telling people that there was a France outside of Paris, and Elliott made it look authentic."

The photograph on page 61 retains a spontaneous charm in spite of the fact that the assistant had to pedal back and forth nearly 30 times until Erwitt was satisfied with the precise composition. The boughs of the trees overhead allow a funnel of light to direct the viewer's eye to the rider, whose legs are curiously cocked askew to suggest the way a provincial farmer, not a professional cyclist, would ride. The tiny passenger is perfectly framed against his uncle's broad back. And all this came together at a precise focusing spot that Erwitt had marked with a stone on the pavement.

Extraordinary attention to detail is what Bernbach calls "the mark of the true professional." "Elliott has wonderful discipline," he says. "I always get the feeling that whenever he does something, he wants to do it better than it has ever been done before. He has a wry sense of humor that never fades. He is totally lacking in the superficial temperament of those who presume to be great artists. What I love about Erwitt is that he is a workman as well as an artist."

Erwitt seems to inspire an awe in people. Ogilvy unabashedly calls him "one of the half-dozen greatest photographers who have ever lived." Even Casals, whom Erwitt eventually photographed for the Puerto Rico campaign (pages 62-63), was so moved by the ad with the cello and chair that he had it framed and hung in his house.

There are people, of course, who have had days with Erwitt that they found less than delightful. Several agency workers below the rank of president remember times when he has been sullen and uncommunicative. Erwitt admits it. "The advertising busines is, by and large, a fear factory. People are constantly wondering about the future of their jobs. There's a lot of ass-kissing and hand-holding. This is something I do badly, so working with the normal run-of-the-mill agency people has been difficult for me. I'm just not good at playing their games. Since I started a long time ago, I've been lucky to get involved with people at a rather high level who are secure in what they're

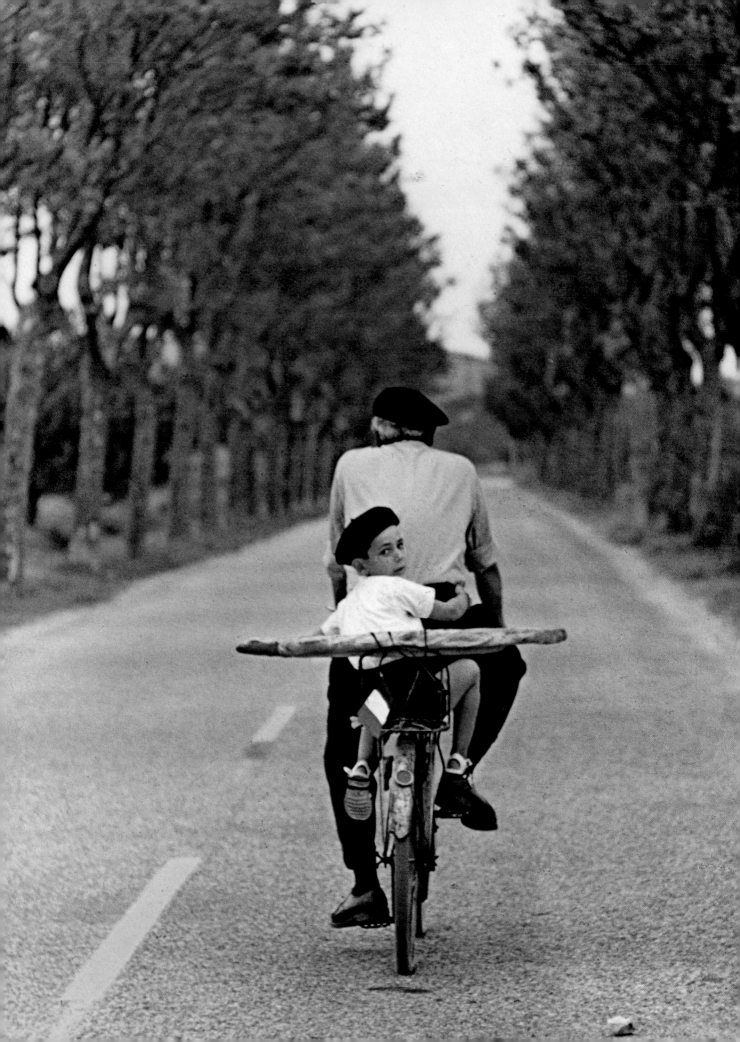

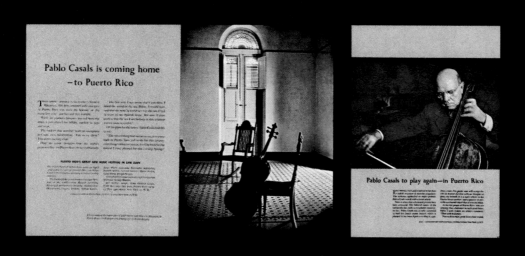

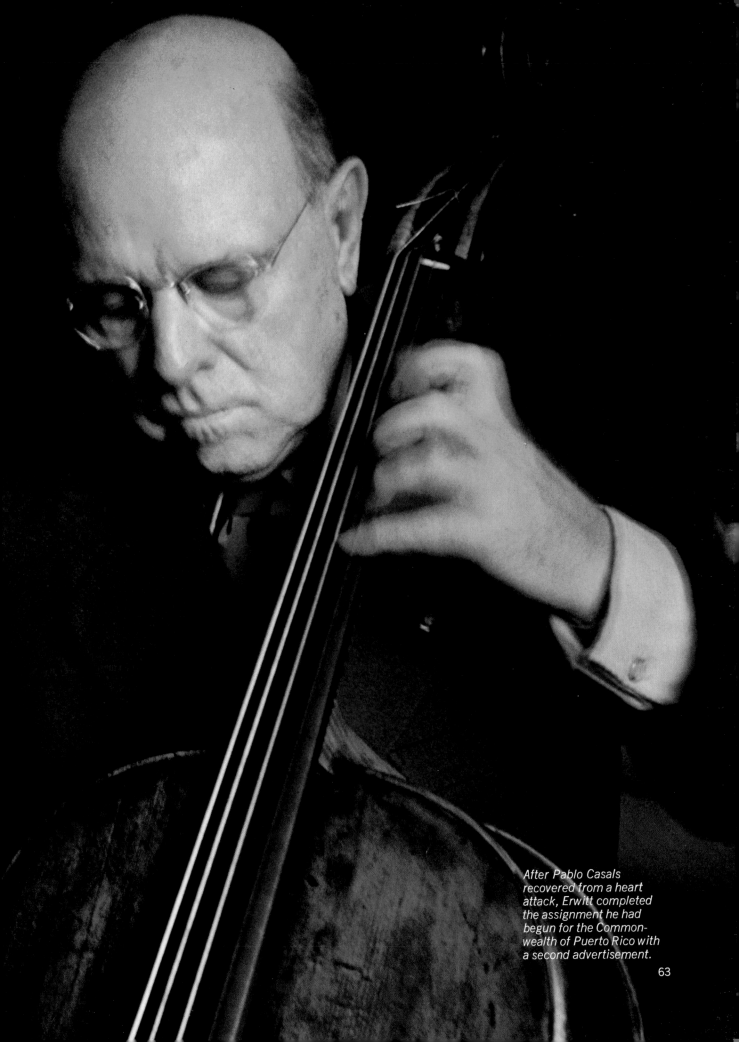

After Pablo Casals recovered from a heart attack, Erwitt completed the assignment he had begun for the Commonwealth of Puerto Rico with a second advertisement.

doing. But when you're dealing sometimes with the troops who think that their jobs depend on every click of the shutter it becomes difficult. I'm serious about what I do, but I might make a joke about it, and the light approach to what is so important to them occasionally makes them uneasy."

Erwitt's technique for reducing tension in the middle of a job is to start dropping puns with brutal abandon. It becomes infectious, with the whole set usually joining in. But few are able to one-up Erwitt. Perhaps because English is his fourth language, he is able to stand apart and, as in his photographs, analyze the oddities and juxtapositions of the language. After a particularly tedious job in his apartment one day, an art director was leaving and paused to notice the overbearing moose in the foyer. As the elevator came to take him away, Elliott said, "Yes, we call him Mickey." The art director rolled his eyes upwards, as if to call for divine intervention. Just as the elevator door closed, Elliott squeezed in another. "But you can call him by his nickname—Chocolate."

Erwitt's ability to extract lifelike situations out of staged events led to his typecasting as a skilled director of elaborate production shots. One of his earliest successes was for a Martell cognac cam-

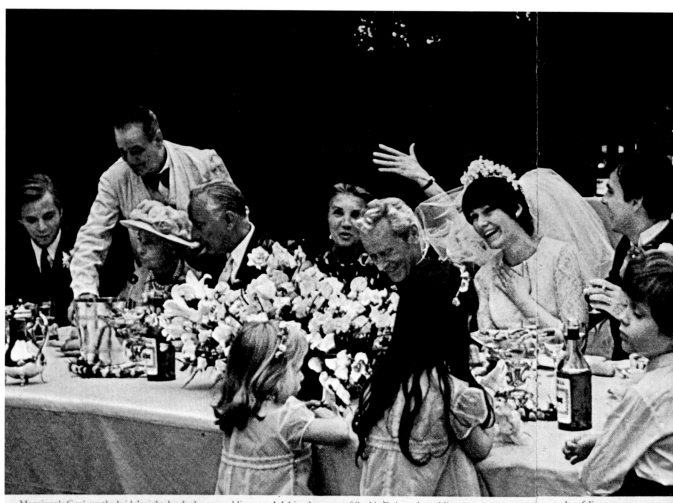

Monsieur le Curé, on the bride's right, has had more wedding breakfasts than most people have had hot dinners.

He eats them out of doors usually as is the French custom. And always after Lent.

Like most Frenchmen, he has a photographic memory for food.

Ask him the menu of Sophie Doignon's wedding seven years ago and he'd recite it to the last olive.

The bride's mother, wearing the cart wheel hat, helped cook his most recent memory.

It took 5½ days to prepare. And 3½ hours to eat. Here it is, in order of disappearance:

Hors d'œuvre. Lobster. Quai (very simple). A cheese board tw cake. And bowls of sugared almon

The two fathers did get a l

paign that ran throughout Europe in the mid-Sixties. In the example reproduced here, a wedding has been staged on a French country estate with a cast of 20. Everything—gossipy in-laws, the dawdling flower girls and the unattached hand gesticulating in the air—have been carefully prearranged to give the look of spontaneity.

Composition, styling and technique play an important role, but the real secret of the picture lies in the charm, personality and wit of the photographer who is able to elicit the proper emotions from the models when and where he wanted it.

"One of my best advertising jobs," Erwitt says with the look of a satisfied

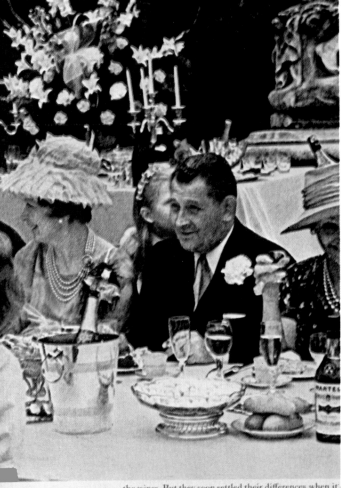

ub (very complicated). Salad big as her hat. Ice cream. The

eated in the cellar choosing

the wines. But they soon settled their differences when it the cognac.

As all Frenchmen know, one cognac has the ines advantage of being blended from the largest and oldest vintage cognac in the world. Martell.

The French themselves rink more Martell cognac than any other brandy.

Recommended retail prices. Cordon Bleu 95/- Three Star 62/- Medallion

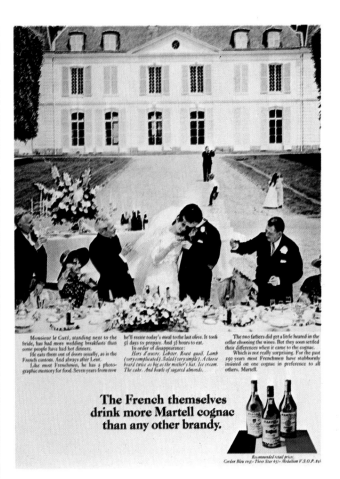

Monsieur le Coté, standing next to the bride, has had more wedding breakfasts than some people have had hot dinners.

He eats them out of doors usually, as is the French custom. And always after Lent.

Like most Frenchmen, he has a photographic memory for food. Seven years from now

he'll recite today's meal to the last olive. It took 5½ days to prepare. And 3½ hours to eat.

In order of disappearance:

Hors d'oeuvre. Lobster. Roast quail. Lamb (very complicated). Salad (very simple). A cheese board twice as big as the mother's hat. Ice cream. The cake. And bowls of sugared almonds.

The two fathers did get a little heated in the cellar choosing the wines. But they soon settled their differences when it came to the cognac.

Which is not really surprising. For the past 250 years most Frenchmen have stubbornly insisted on one cognac in preference to all others. Martell.

The French themselves drink more Martell cognac than any other brandy.

Recommended retail prices. Cordon Bleu 95/- Three Star 62/- Medallion V.S.O.P. 84/-

Two different photographic angles of the same setting produced entirely different effects for a Martell cognac advertising campaign.

businessman, "was for IBM when they wanted me to go down to Brasilia to take a picture of a clock face against the background of the city. I brought the clock-face with me mounted on a piece of plexiglass. While riding in the taxi from the airport to my hotel we happened to pass a place where I thought the picture could be made. I asked the driver to stop so I could shoot for a while, and before I checked into my hotel the job was already finished. Then I proceeded to float with the wind. I got some of my best personal pictures there, one of the strongest groups that I've ever made. Just before I was to leave I read in the paper that a ship had been hijacked and seemed to be heading for northern Brazil. I quickly flew to Rio and wired Magnum my whereabouts. Shortly thereafter they got me an assignment for *Stern.* I flew up to Recife where I joined about 350 news- papermen from all over the world who had the same assignment I did. I shot the story and then realized it was getting to be carnival time, so I returned to Rio to make some pictures for my stock library at Magnum. They sold well, and are still selling today. While there I photographed a

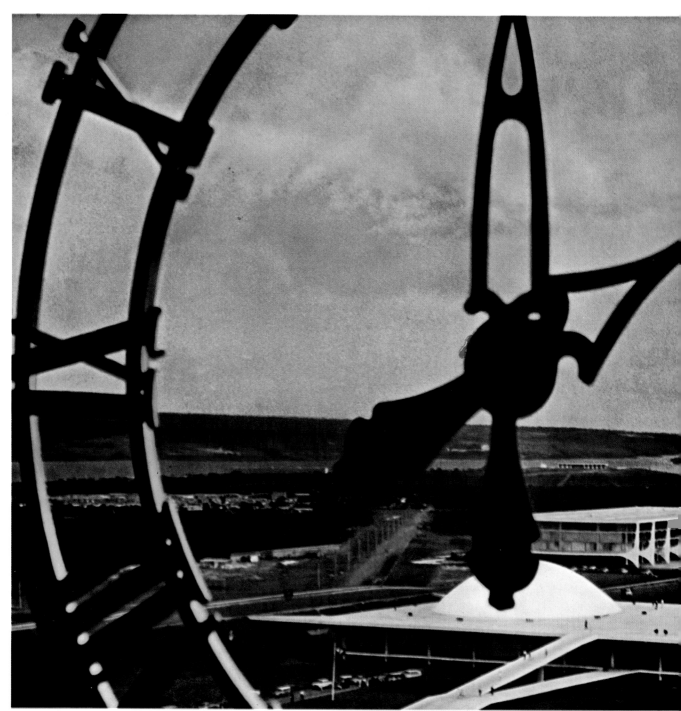

box of Oxydol soap that I'd been carrying with me for a month. The Oxydol people had wanted a photograph of the box with some white sheets against a foreign setting. They originally sent me to Europe, and when I arrived the whole continent was covered by clouds. I decided to go to St. Moritz because the locale was up high, and I hoped to get above the weather. But when I arrived in St. Moritz it was just as bad. I kicked around a week, waiting. I bought some clothes, went skiing and took some pictures on my own. When the weather didn't improve after a week, I returned to the U.S. Shortly thereafter I got the IBM job, so I had brought the soap along just in case. In Rio I spread some sheets out on a golf course and finally finished the job. After Rio I picked up a quick little job in Peru so I hopped over there, then flew home. That was a pretty good month."

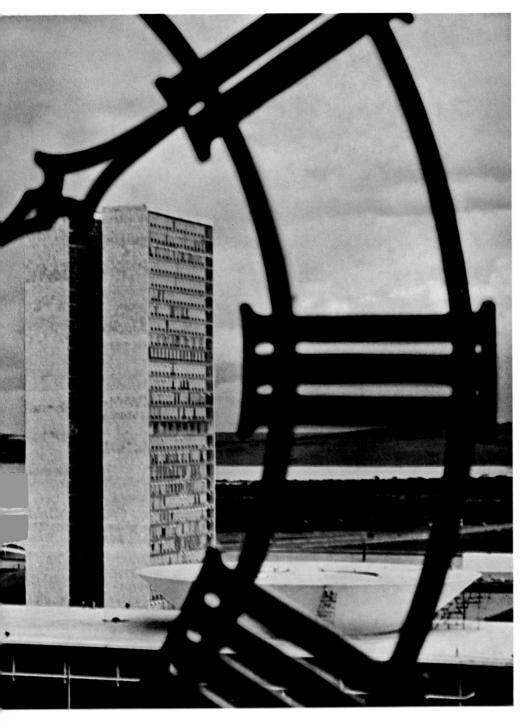

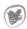

Architecture: Being fair to buildings

What was it, then, that made photographer Elliott Erwitt—a success in the worlds of art, journalism and advertising—try his hand at architecture?

"Well, I was between jobs and needed a solid piece of work." He heard about a project to photograph the 150 most important buildings in the U.S. for an exhibit at the World's Fair in Osaka. "I hadn't really done much architectural work before, so I went in and told the project designers that I was a great architectural photographer. I am interested in architecture. I built my own house, and had done some work for *Architectural Record.* I gave them my body and they hired me."

Erwitt instinctively saw beyond the immediate goal of the project and began thinking about a book (which was published two years later with the title, *Observations on American Architecture*) as well as the significant addition it would make to his stock library. He chose to photograph the buildings in a classical way with a sense of place.

"I wanted to put the building in its site in a traditional manner. It was really the simplest thing. Try to find the best angle, the best view, whatever, and make a straight picture with all the lines reasonably straight. I'd always try to take a picture of a building "flat-footed" —in the same plane that it was originally drawn. I hate pictures that distort an architect's work. There are times when you can't, help it, when there just isn't enough space to get the camera back far enough, but you should try to see a building as well as possible, I think. "Only after I had the building framed as clearly as possible would I add something to try to get in scale."

At Wounded Knee, S.D., he captures the sense of place for a rude church that takes on extra significance when cast against the vastness of the prairie.

An office building by Mies van der Rohe, located in downtown Chicago amid a clutch of undistinguished brownstones and warehouses, presents a problem for the photographer. In their renderings, architects always depict their buildings towering in the open

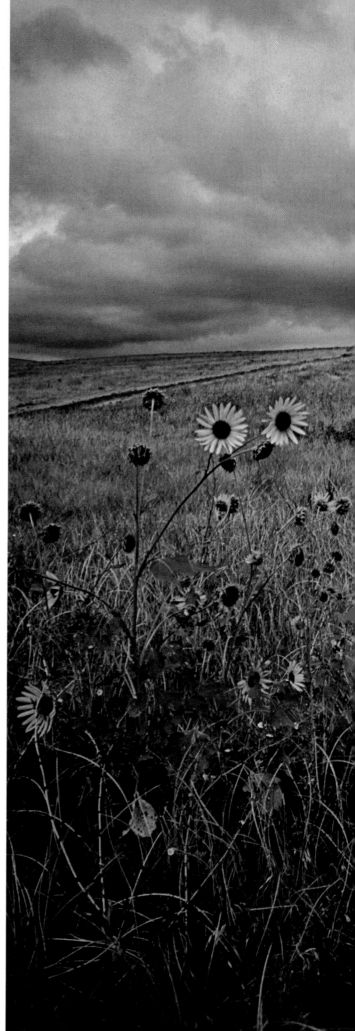

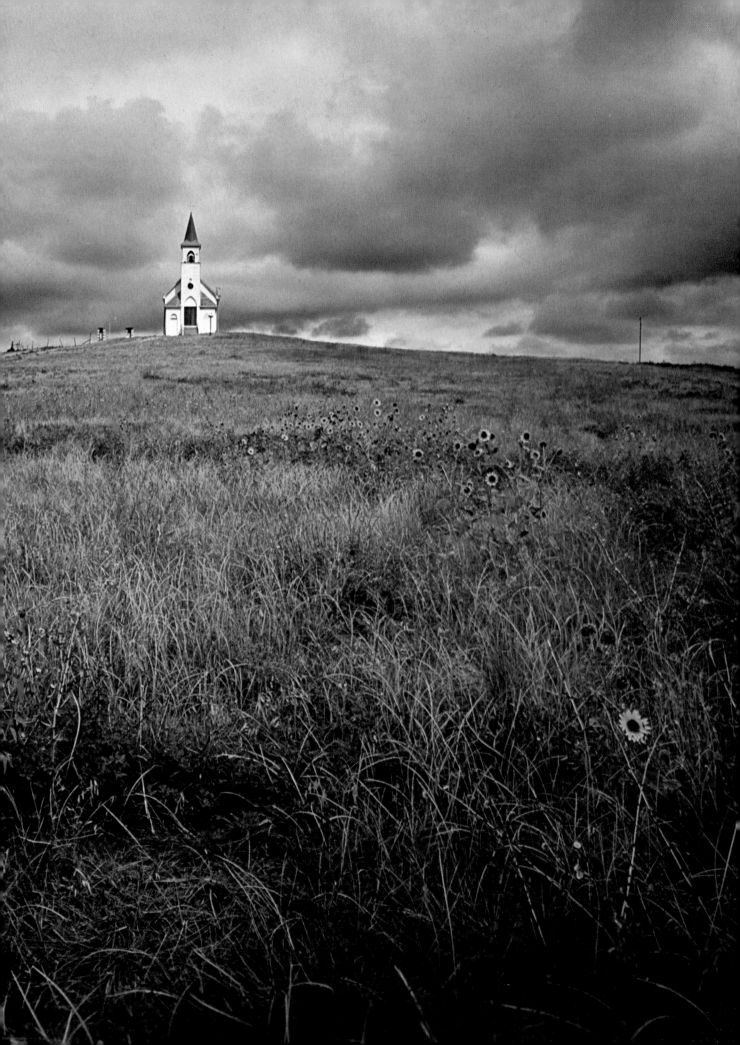

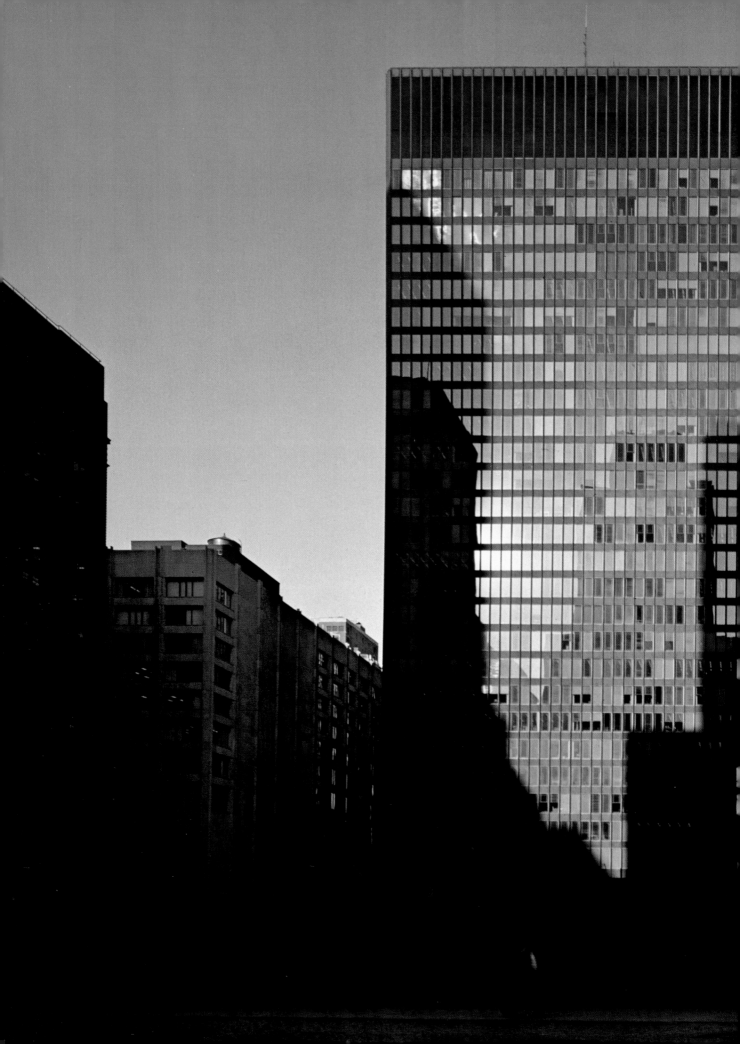

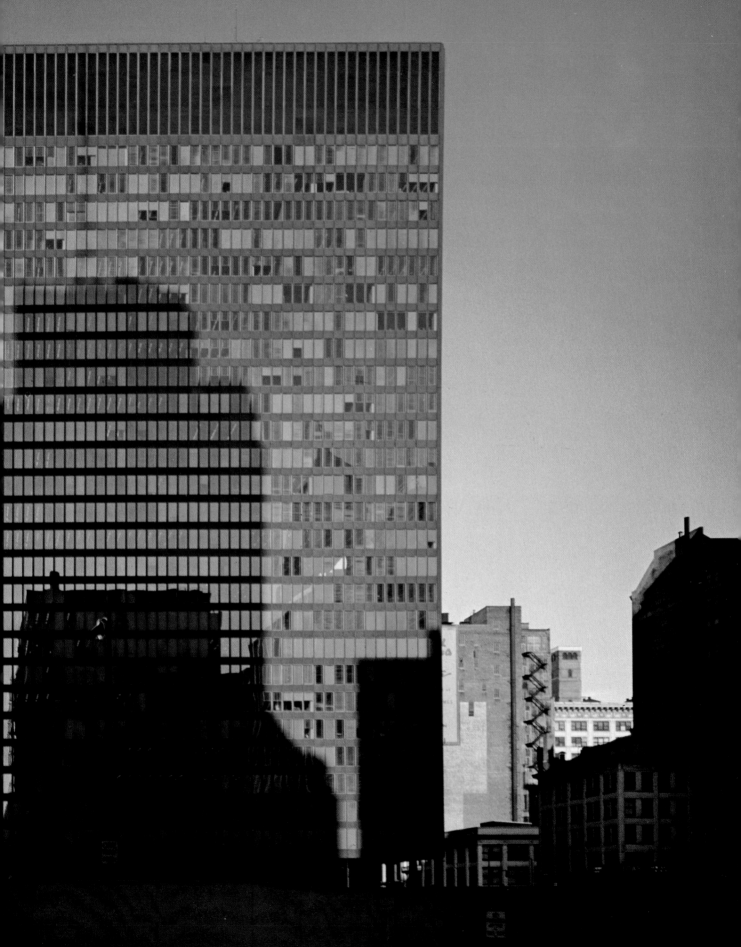

air, but when the photographer comes to make its picture, he often finds the structure mired in urban blight.

"You can't just walk up to a building and take a picture of it," says Erwitt.

"You have to get up early to see it in the morning light; you have to navigate around it, figuring out its best angles, its worst; there are even times when you have to figure out a way to flatter it a little. It's much more subtle, and I guess more dull, than other kinds of work—I mean, you can't get a building to giggle or compose itself. Taking pictures of architecture is a lot like taking pictures of sculpture or still-life, only you can't move it. Here, you make it move by finding the angle and finding out where the sun will be."

Erwitt photographed the van der Rohe building in an afternoon light that

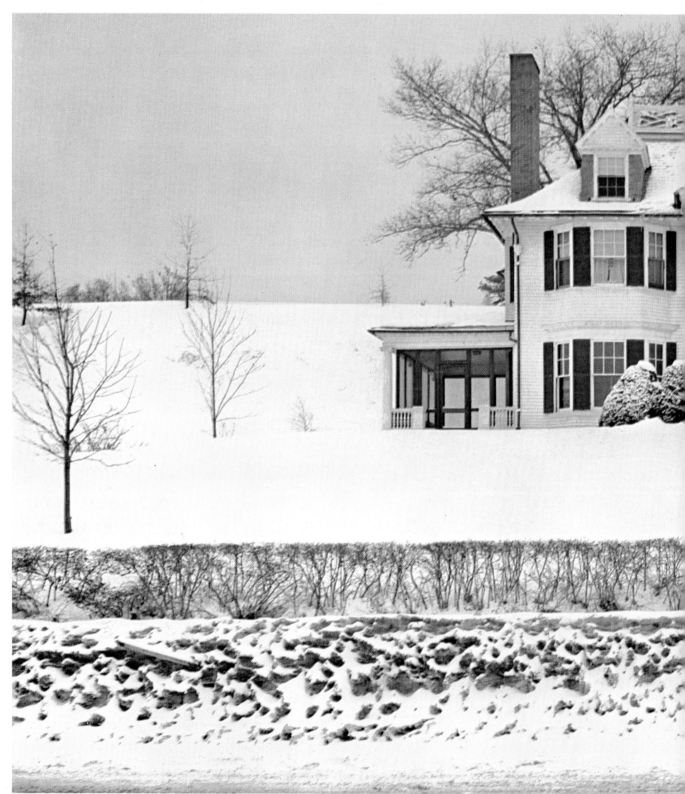

subdued the lesser structures to mere silhouettes and made the subject loom out of its surroundings. A catchlight in the form of a lens flare added extra emphasis.

Another unconventional stylistic device is the fillip a passing equestrian adds to an elegant New England home.

"Any human manifestation, correctly placed, gives it better perspective. Sometimes it can be a little dog walking by. There are a number of pictures in the architecture book that have dogs in them. It is no accident. They bring a touch of life to the building."

It is worth noting that for a period, *Architectural Record* hired the nation's premier architectural photographer, Ezra Stoller, to photograph buildings. Then they would hire Elliott Erwitt to show the people using them.

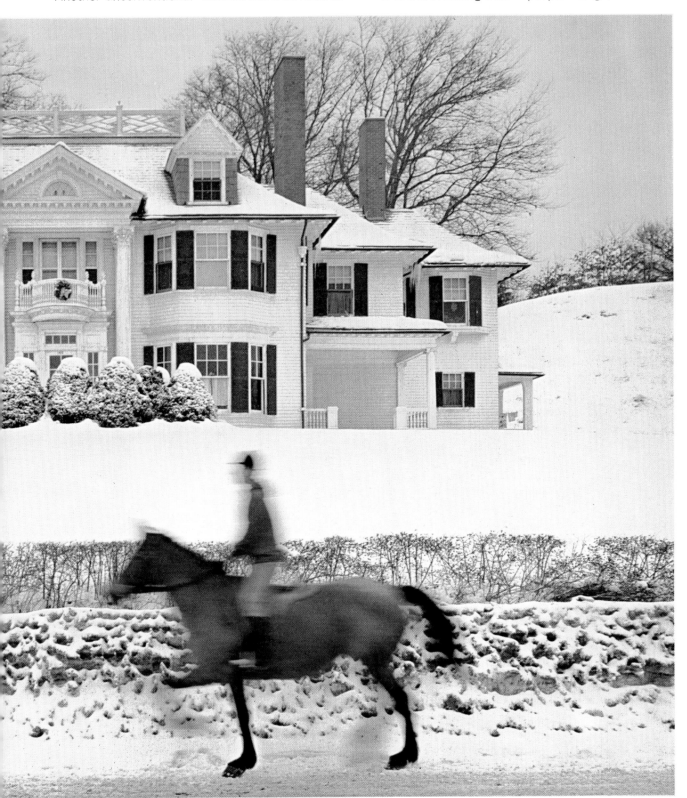

Letting people be themselves

Since the ninth century, when the Normans introduced feudalism to Sicily, a rigidly defined aristocracy has existed there longer than anywhere else in Europe. In 1956, Prince Giuseppe Tomasi di Lampedusa wrote an elegy for it in a novel about his family entitled *Il Gattopardo (The Leopard)*. He died before its publication, missing the financial rewards and critical acclaim that came to it. His widow, Countess Wolf-Stomersee, still lives in the crumbling family palace amid Renaissance splendor, with but a few servants to comfort her.

Now in the final stages of decay, Sicilian aristocracy was a ripe subject for a picture story, and the London Telegraph assigned Elliott Erwitt to the task. It was natural to start the story with the countess, but she vehemently refused to be photographed. After he repeatedly sent her bouquets of roses, she agreed to meet with the reporter-photographer team, but only as a courtesy.

Erwitt knew that if he went in with a view camera and photofloods he wouldn't have been able to open his case before being thrown out. He carried just his Leica. While the countess was making up her mind about whether she would permit him to photograph, he started shooting with existing light. "I made a few exposures just to have them, because she had to be represented somehow or we didn't have a story. I made six before she asked me to stop."

The countess had decided she didn't want to be photographed, so the picture reproduced on pages 76-77 is really of her thinking over whether or not she should allow it. By relying on a hunch, a little luck and some cunning, Erwitt completed the assignment, perhaps mindful that editors rarely ask a photographer *how* he got a picture; the question is, *did* he get the picture?

In this poignant story of impoverished aristocracy, Erwitt makes "environmental portraits" in a candid way, without heavy-handed styling.

"I received an absolutely great education once when I watched Karsh making a portrait. He thoroughly researches his subject ahead of time, getting to know the wife's name or the man's hobby, and he uses this information to the hilt. He's the ultimate flatterer. If the man likes to fish, Karsh will talk endlessly about fishing, while all his assistants are running around carrying out his instructions. He establishes presence with that 8x10 view camera—which is silly these days for making a portrait. There is an immense stack of 8x10 holders nearby, and to complete the act the camera is painted white. That's his *schtick*. It is very impressive."

Erwitt rejects the technique of some environmental portraitists who use people as furniture, placing a subject precisely the way the photographer wants in the subject's own environment. "It seems to me," he says, "that you should always let people be themselves."

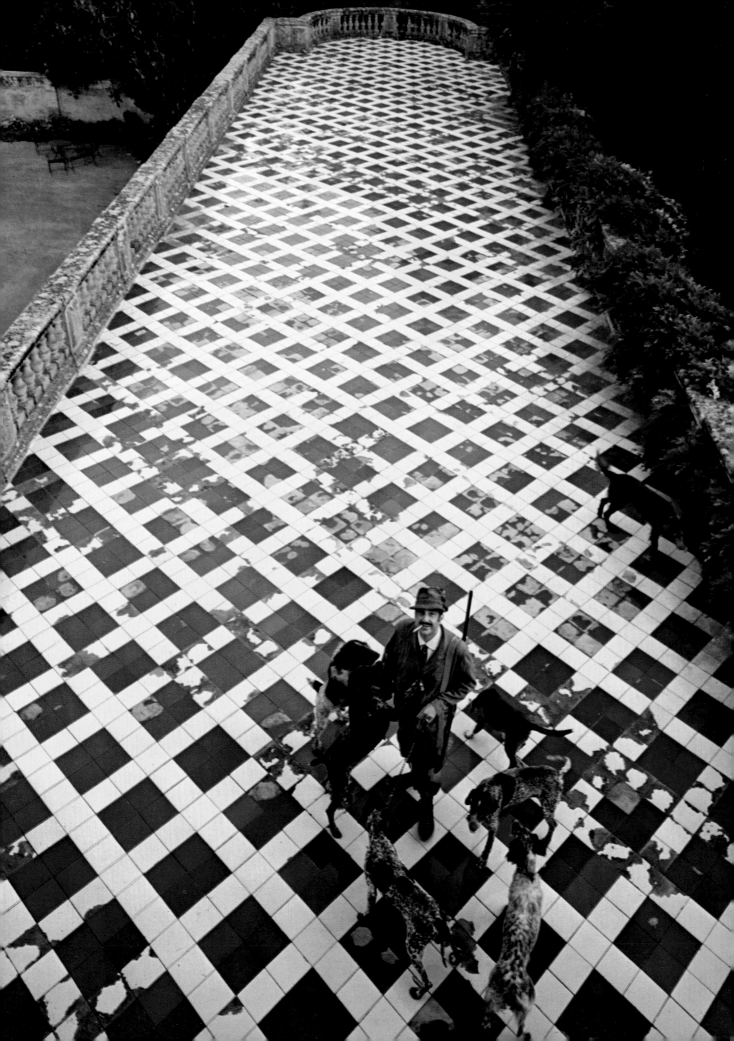

Films

"I always knew I was a filmmaker—even before I became a still photographer," says Erwitt, alluding to those days when as a boy he would skip classes and hide out in the basement movie theater of the Museum of Modern Art. It was more than 30 years later when he made his first movie—a 16-minute promotional look at the making of the film *Little Big Man.* Actor Dustin Hoffman recalled being impressed with Erwitt's professional mien. "Most outsiders on a movie set can't help making their presence known. Elliott didn't. He blended right in. The film he made was, in its own right, every bit as good as *Little Big Man,* by far the best of its kind I have ever seen. I'd like to see him become a film director."

Erwitt used the opportunity to make two additional short documentaries about both Hoffman and director Arthur Penn, which he financed himself. Although they gave him valuable experience, they caused such a financial drain on his business that it was over two years before he was able to recover. His next effort was a half-hour documentary on the Kilgore College Rangerettes, a woman's drill team in Texas widely known for its half-time exhibitions at football games throughout the South. Entitled *Beauty Knows No Pain,* it was financed in part by CBS, which used a small segment in 1971 on its television show, "Sixty Minutes." Again, Erwitt went beyond his original concept and went into debt, but the film has been widely praised as a stunning social documentary. In the same audience one can uncover viewers who see it as a scathing, condemnatory profile of middle-class values and others who see it as a laudatory paean to All-American virtues. Erwitt's approach is to play it as it lays.

Although it will be years before *Beauty* recoups its investment, it was the vehicle that got him a grant to produce *Red, White and Bluegrass,* a half-hour documentary on country music. *Bluegrass* completed a reel of sample films—equivalent to a still photographer's portfolio—that has since propelled him into the lucrative world of TV commercials.

Florence Sillen, an agent with Barbara Fine, an independent producer of commercials, forecasts a bright future for Erwitt. "His heightened sense of reality makes him shy away from the gimmicks or pretty pictures so often used in this business. There is a market for his kind of talent. Erwitt can find a picture, regardless... he doesn't have to resort to a sunset."

The word "versatility" continues to crop up in Erwitt's conversation. It is the cornerstone of his career. Regardless of his success in films, architecture, advertising and photojournalism, those forms all tend to serve his personal pictures. The visitor has returned to ask him about the delicate balance he maintains between his private and public worlds. Outside the cluttered office of his apartment lies a doormat emblazoned "Go Away." There is hardly room for more than two people inside. It is a maze of stacked camera cases, film reels, equipment and print boxes. In the midst of this he is packing to go to Europe for two weeks.

"It is really hard enough to do one thing well," he says. "You have to devote yourself totally to what you do, if you want to be successful at it. Straddling both worlds becomes really difficult. From a purely practical point of view, this works to my disadvantage. Art directors are used to dealing with specialists. They are very comfortable with someone as long as he sticks to what he's good at. But someone versatile tends to confuse them. They don't know where I'm coming from. From a purely personal view, though, I prefer it. I couldn't exist otherwise."

"What is so nice is that I have a choice. Even right now I've just finished shooting these commercials for a truck company. I could decide tomorrow to go to Abyssinia to cover the drought there and be sure that it would be worth my while. It might come in the form of a guarantee from *Newsweek,* or a plane fare from *Stern.* It would be a reasonable thing to do, and I could be guaranteed having it see the light of day. This is what I've paid for all these years by working myself into a position of total versatility, so that I can do anything I want to at the time I want to do it. Whether I do it or not is another question. To have the possibility is the absolute essence of my entire attitude about the profession."

But what, the visitor wants to know, does all this frenetic lifestyle do to one's private life? The fierce dedication, the trips, the irregular hours tear at a marriage. After several years, Lucienne and Elliott separated. Between wives he had an intensely productive period of constant work and travel with a striking multilingual Brazilian-Dutch fashion model who became his assistant, model, arranger, driver, schlepper and girlfriend for 4 years until they parted of sheer exhaustion. Four years later he married Diana, a woman more geared to his lifestyle. But the pace is beginning to wear on this marriage too.

"I always thought that being a photographer would be the most wonderful thing in the world, particularly at my stage now. My children are nearly grown, and I'm in a position of choosing where I want to be and what I want to do. I can immerse myself in real situations, whether it is art or history or politics, because I'm a photographer. I can find a reasonably good reason to go practically anywhere. But photography is really a hard act to follow when you have a family. So many things are contradictory, and so many things have to give. The priorities are what get you."

Erwitt takes a break and lights up one of his favorite Dutch cigars. The visitor asks, "If given some time to yourself, what would you most like to do?" Erwitt takes a puff and gives a long, thoughtful look into the cloud of smoke he's just made. "I think," he says, "I'd like to put my closet in order. I've lived in this place four and a half years now and still haven't got it straightened out. Then I'd like to go off to some warm place and sleep

for a while."

The phone interrupts his reverie. It's a young photographer wanting to show his pictures. Elliott warns him that there is not much advice he can give, but agrees to see him when he returns. He does this willingly. It's called paying your dues. But the young photographer must be ready to get up at dawn for a 7 A.M. appointment. During his rare visits to his own home, the phone rings constantly, so that the only time he can conduct personal business is before breakfast. Such necessity tends to weed out all but the most dedicated. On the bulletin board is a card from a recent visitor. Erwitt kept the young photographer's name up there not so much because he thought the man was a particularly brilliant young talent but because he looked like a "terrific boyfriend" for Erwitt's daughter.

The cult of admirers of Erwitt's work is growing. Recently a young photographer came from Chicago to show him a

set of pictures he had made of people reading Erwitt's *Photographs and Anti-Photographs* book. Another correctly interpreted his feeling for dogs by sending him one —to his delight—stuffed and mounted.

Usually he tells aspiring photographers that their best chance for survival in this business is to not have to do it for a living. Then he cautions, "A guy shouldn't have a family unless he is rich. If he comes into this business with a wife and kids, and wants to be a serious photographer, the market is pretty bleak. If you've got no responsibility and don't have to generate a certain amount of cash each month, and can live on a shoestring, and are ambitious enough, then you might have a chance. You can be dedicated, but that is no guarantee that you'll make it."

If he has anything to offer, he says it is not his art, but the example of his lifestyle that enables him to do what he wants to do.

"Things may look very confused around here, but there is direction to

what I do. Over the years I've developed a fairly accurate sense of balance and timing on when I should move on to another thing. After being in one place for five weeks or so, I know that I will want to be somewhere else. I need distance to refresh myself. I have an annual report to shoot this time in Europe, but it is one that I actively looked for that would get me over there at this time. While I'm there the three commercials I just shot will be put together, so when I return they will be finished and ready for the screen, which will be a nice surprise. I have an exhibition opening in London, and there are some clients there that I like to drop in on at this time of year. Also, a European publisher wants to talk about a book. Coincidentally, I need a new bathrobe and another bush jacket (I go through two or three a year) which I get at Moss Brothers in London. My shoes should be ready at Church's from the last time, and I'm deferring my haircut for Italy. And . . . the plane ticket

I'm using happens to expire today.

"It's been a long time since I've been able to make my own pictures. All that has been going on in the past few weeks has been for the administration of my business. It is allowing me to live. It is essential that I make up this exhibition for England, that I put together a dog book for Viking, that I shoot these TV commercials—but it hasn't really been productive. The only really productive thing is taking pictures."

Erwitt then shooed the visitor out so that he could have a few quiet moments to run through his mental checklist of what had to be done for the next two weeks. He then packed his cases and left for Europe.

As he was leaving, the visitor recalled that night of the party at which he first met Erwitt. He had left late—Elliott had long since gone to bed— and as he was going he spotted on a clothes trunk the jacket Erwitt had been wearing earlier and a bushy black wig. It then dawned on him that for some inexplicable reason Erwitt had on occasion been wearing a wig that evening. Haas has said that the people in Erwitt's pictures seem to be affecting masks, that if they weren't actually wearing disguises they were miming them in the form of stereotypes, and then he added, "There is something Chaplinesque about him, and something from Buster Keaton. There are a lot of the qualities of the great silent comics which are condensed in Elliott's personality. He wears baggy clothes, and once his hair was like Harpo's. Harpo never talked either. He, too, spoke with his instrument. Yes . . . I think Elliott is a Harpo with a camera."

Technical section

Behind a quiet personality, Elliott Erwitt conceals a vast amount of technical knowledge. No matter what the situation, he has taken pictures that look natural and unposed; the easy candor with which he takes them grows from an ability to integrate his fund of technical knowledge with his personality so skillfully that an observer might never notice the photographer's presence, to say nothing of his technique.

Some pictures take careful planning and meticulous arranging. But Erwitt's personal style also depends strongly on other pictures that appear suddenly before the camera. At such moments, does he even remember technical information as such, or has he absorbed it all so thoroughly that he can act almost without thinking? Despite the snapshot character of many of his photographs, all reflect a profound knowledge of equipment, light, and photographic technique that has become second nature to Erwitt.

The tools of his trade are simple but comprehensive. They can be divided, roughly, into two areas covering his personal, candid, black-and-white pictures, and his professional pictures.

For "personal" photography—candids such as his family pictures, anti-photographs, the images he calls snapshots—Erwitt carries one small rangefinder camera—not two or three with different lenses, just one Leica M3 body with a selection of lenses. For many years he used a Leica 3C and a 3G. Now, he still uses the Leitz collapsible lenses—a type no longer manufactured—that he used with his older cameras. He likes these lenses because they protrude very little when collapsed, so he can easily slip the camera into a pocket where it rides comfortably and unobtrusively. After all, the Leica was designed as a portable camera, and Erwitt's use of the old collapsibles keeps his instrument portable to an extent that is true of few professional-quality cameras today.

His standard lens for personal picture-taking is a 50mm Summicron f/2 collapsible. He also has a 35mm wide-angle, and a 90mm telephoto. He rarely shoots anything but black-and-white in this camera. For many years he used the old Eastman Kodak Super XX film; now, he uses Tri-X, rated at ASA 400, most of the time.

Since the Leica made its first public appearance at the 1925 Leipzig Spring Fair, 35mm cameras—and especially the rangefinder types—have been favorite tools of candid photographers. The burgeoning popularity of single-lens reflex (SLR) cameras has led major manufacturers such as Canon, Nippon Kogaku and Zeiss to abandon most of their rangefinder lines, so that today E. Leitz is the only one to offer a really sophisticated rangefinder camera, the Leica. Erwitt prefers it for candid personal pictures because he likes:

1. The quick focusing of the rangefinder/viewfinder system. Since the sole function of the lens is to transmit light to the film plane, he views and focuses through a separate clear window in the top left side of the body as he sees it from behind the camera. Looking through the window rather than through the optical system of the lens, he can obviously see a subject clearly in bright exterior light; but he can also see and focus quickly even in dimly-lit interiors where a rangefinder can provide more critical focusing than a through-the-lens system.

2. The quiet shutter and almost vibration-free mechanism. Erwitt makes many of his pictures in low-light situations that require slow shutter speeds. Since an SLR gathers light through the lens and casts it via a mirror into a pentaprism viewfinder, the mirror has to pivot up and out of the path of light at the instant of exposure, and the slight vibration this movement causes in the camera can result in lack of sharpness during long exposures. The rangefinder camera has nothing blocking the path of light, so no mechanism is needed to remove a mirror. The only movement during an exposure is the opening and closing of the shutter.

3. To see his subject at the moment of exposure. A photographer who has been seeing a subject through the lens is momentarily "blinded" when the mirror of an SLR flips out of the way, but the Leica, with its viewfinder separate from the lens, lets Erwitt keep his eye on the subject.

For most of his "professional" still photography—the pictures he makes for money—Erwitt has reduced his equipment arsenal to the contents of one case weighing approximately 32 pounds. Except for a tripod, which he keeps in a separate container with his film, this case holds all the camera equipment Erwitt needs for most of his professional jobs. In it are two SLR cameras—Canon F1s—and one lens of

Canon F-1

each focal length made for the Canon from 17mm to 300mm. Also in the case are a cable release, which he considers essential for slow shutter speeds, and a Minolta

Erwitt's complete traveling camera case with Canon cameras and lenses

17mm 100mm 300mm

auto-professional light meter, which he bought recently after using a Metrastar meter for years.

The case also contains an Eastman Kodak pocket guide to photography that Erwitt has carried around the world many times, which, he says, "gives me all the technical information anyone will ever need to make a photograph." This Master Photoguide, pocket edition, is Erwitt's handbook. It includes charts and diagrams for all types of light sources: daylight, photofloods, flash bulbs, electronic flash. Its charts cover depth of field, color temperature, filters, contrast, exposure data, ASA ratings for various films, and much more.

In a second case, Erwitt carries a Tiltall tripod which he has had slightly adapted; the adjusting handles and screws have been machined down so they will not break off during travel and rough use. The case also contains his film supply—Kodachrome 64 for most exterior use, high-speed Ektachrome Type B for interior use with artificial light, and Kodak Tri-X for most black-and-white situations, inside or out.

In a third case, which Erwitt takes on special occasions, is a view camera. Instead of the more conventional 4x5 and 8x10 view cameras, he travels with a small Plaubel designed to use 2¼x3¼ cut film quite similar in size to 120 roll film. He has replaced the cut-film holders that usually go into the camera with a roll-film

back that takes either 120 or 220 film and allows him to work more quickly than he could with a standard view camera. He can make eight exposures on one roll of 120, or 16 on a roll of 220, concentrating on the picture instead of repeatedly changing cut-film holders.

Erwitt uses the view camera for many architectural pictures, and for other situations in which he wants to correct perspective, distortion, and depth of field with adjustments that only a view camera can make as its front lens board rises and falls, shifts left and right, tilts about a horizontal axis and swings about a vertical axis; as its bellows expands and contracts; as its film plane, commonly known as the back board, tilts and swings.

With a black cloth covering both his head and the back of the camera to give him a sharp view of the image on the ground glass, Erwitt can compose the picture he wants, as long as a subject stands still for him to do it.

Erwitt recently added some of the advantages of a view camera to his single-lens reflex equipment. He bought a Canon wide-angle lens that tilts (to increase depth of field with subjects at an oblique angle such as books, trains, or walls) and shifts (to correct the effects of perspective, as when shooting up or down at buildings). In addition to this 35mm lens, he has ordered a 28mm Nikkor with some of the same properties and will adapt it to his Canon cameras.

Erwitt does not believe in

**Canon TS Lens
with tilts and shifts**

flash bulbs, strobe, or any other type of light that he cannot see continuously. Rather than bring in a big battery of lighting equipment, he prefers to supplement existing light so that the film will read the situation as closely as possible to the way his eye does. As a result, he has reduced his equipment for artificial lighting to the simplest of all: incandescent bulbs, whose light he can not only see and study before making an exposure but can balance to whatever existing light is falling on the subject. Because he dislikes carrying big loads of equipment on his travels, he has stashed sealed-reflector photofloods, both daylight-type and tungsten, in different cities around the world. Because, he argues, different countries tend to have different voltages and different types of sockets, and the bulbs are easy to replace, it makes more sense for him to leave a set of lights with a friend in Paris, another set with a friend in London, another in San Francisco, and so on around the world. His total investment in this global array of lights is $150.

Erwitt's style, both personal and professional, is to pare away whatever he considers non-essential. His equipment, therefore, is the bare minimum he needs to take the pictures he wants. He uses his tools with an

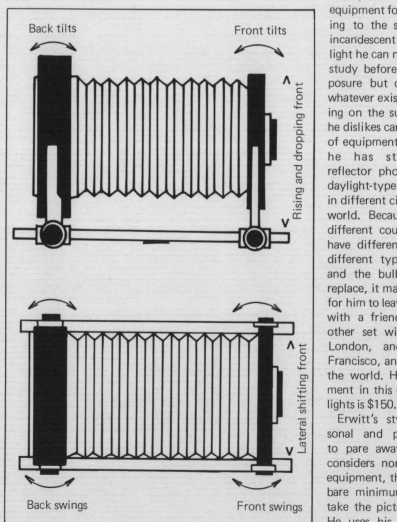

Back tilts Front tilts

Rising and dropping front

Lateral shifting front

Back swings Front swings

imagination and flexibility born of a mastery of technique, but technique per se never dominates an Erwitt photograph. He uses technique not to show off but to serve his concepts; his pictures are subject-oriented, not technically oriented.

AVAILABLE-LIGHT PHOTOGRAPHY: THE SPECIAL PROVINCE OF THE RANGEFINDER CAMERA

Early "miniature" cameras such as the Ermanox, which made pictures on one single glass plate at a time, and then the Leica, which made them on a roll of 35mm film, gave photographers in the 1920s a chance at a new kind of candid, unposed picture using whatever light happened to be available at the moment. One advantage such cameras introduced was high-speed lenses. Coupled with the more recent introduction of high-speed films offering fine image quality, they have made it possible for a craftsman like Erwitt to photograph anything he can see.

Practically all his black-and-white pictures are made with available light, under conditions where the light is often relatively low, in situations where a picture could be ruined if the photographer or his camera intrudes on the subject—for example, his first wife and child on pages 4-5 and 18-25; the ranch family on pages 26-31; personalities including Richard Nixon and Nikita Khrushchev (pages 50-53) and Charles de Gaulle (pages 54-55); and the people and dogs in the anti-photographs on pages 33-49.

Erwitt's intimate pictures of Lucienne and their first child called for the use of his rangefinder Leica. The light in their apartment was all he had, and it was not very bright. Some photographers like to add "service lights" to such situations, putting extra-strong bulbs in house lamps, but Erwitt did not. First of all, it was his home and he did not want to live with the constant glare; second, "you can't go around suddenly adding service lights when you catch somebody doing whatever they do. You have to take the picture." In such dim, low-contrast situations, the simple optical viewer of a rangefinder camera gives the photographer a brighter, contrastier look at a potential picture than he can get by sighting through a lens and a viewing screen in an SLR. Dim light most often means wide-open (or almost wide-open) lenses. One consequence is a very shallow depth of field, even with wide-angle and normal lenses. That brings out another advantage of Erwitt's rangefinder camera. Its bright viewing image helps him focus more accurately, by bringing a split image together into one, than he could with a reflex system in situations that allow for little focusing error.

Given lighting that is not under his control and is not very bright, a photographer's standard responses are to use a slow shutter speed and to "push" the film by underexposing and then extending development time. Erwitt seldom pushes, if he can help it, so he is left with the option of the longer exposure.

Of that classic technique, technical expert Bill Pierce writes in the authoritative Leica Manual, "Every camera club speaks in awe of a mythical figure, a past member, who could hand-hold longer and steadier exposures than any current mortal. Much of his success was probably due to the confidence this adoration gave him. It is impossible to squeeze off a successful slow-speed exposure if you are tense and worried. Like a good rifleman, exhale and relax. Steady yourself and your camera against any convenient support. Lean against walls or chair backs. Rest your elbows or the camera on the edge of a table. . . .

"Oddly enough, your choice of lenses can help you hand-hold slow shutter speeds. Just as a wide-angle lens reduces the image size as compared to the image produced by a normal lens, it also reduces the visible effects of camera shake. A longer-than-normal lens, on the other hand, makes a camera movement more obvious. Other things being equal, you will probably be able to produce sharp wide-angle shots at a slower shutter speed than your normal-lens limit.

"The tripod," Pierce continues, "is the ultimate slow-speed aid. But when you depend on a large tripod, you sacrifice most of the convenience and flexibility of the small, hand-held camera. A few tripods are small enough to carry conveniently at the bottom of the gadget bag. I say 'a few' because, while there are many small tripods on the market, most of them are really toys. Few are solid enough to hold a camera steady when it is equipped with a long lens and used without a cable release. If you go this route, be sure to buy a good small tripod; don't be surprised when it costs as much as a larger tripod."

Such advice comes not only from Pierce's own experience, but from that of practitioners like Erwitt. "I'm a tripod freak," Erwitt admits with a tiny smile. "I've had more tripods than I've had cameras, though now I've standardized on the Tiltall." Still, in following Lucienne and the baby around the apartment, he seldom used a tripod.

What he did do was to keep a careful eye on where the light was coming from. Despite all that has been said about the problems of darkness in available-light photography, Erwitt does not consider the amount of light to be a problem: "Balance of light is the problem."

Among other things, he is talking about the balance between shadows and highlights that determines where the emphasis goes in a picture. Erwitt always tries to make sure the major light in a picture falls at right angles to the camera, as it does in many of his candid photographs. One example is the famous picture on pages 24-25, in which highlights on the bedspread, the baby's bottom and Lucienne's forehead and cheekbone suggest the relationship between mother and child even though the image does not contain much sharp, detailed information. The darkness of the shadows, by contrast, adds an element of mystery to the scene. Different planes, picked out by the strongly directional light, supply dimension to a black-and-white scene that could have looked flat if photographed with the light hitting the subject head-on.

The right-angle lighting of this picture and others—for just a few examples, the portrait of Lucienne and the baby on page 21, and the wide-angle photographs of them on pages 4-5—is no accident. Obviously, Erwitt has seen what he wanted and

moved into the position he wanted.

Experience has taught him to make those moves almost without thinking of them. He knows that pictures taken in low light might have less shadow detail than normal, certainly less than the human eye ordinarily sees. He knows that film cannot cover the great range of brightness that the eye handles with ease, so he automatically imposes on his own vision the limitations of lens and emulsion, seeing like a camera. In dimly-lit interiors, he composes pictures that do not depend on information that will be soaked up in shadows. He uses the shadows for effect, and puts emphasis where he wants it by noticing where the light will create mid-tones and highlights on a print.

ADDING TO AVAILABLE LIGHT: SILHOUETTING AND CROSS-LIGHTING FOR DEPTH

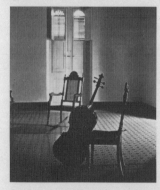

On assignment to photograph Pablo Casals, Erwitt arrived in the Commonwealth of Puerto Rico to find that the maestro had suffered a heart attack and was therefore not available for a sitting. Nevertheless, Erwitt accomplished the seemingly impossible task of making a profoundly moving portrait in which the subject himself does not appear.

While thinking of a way to produce the portrait, Erwitt had to answer many technical and conceptual questions. The first was: How do you represent the man without his presence? Fortunately, there was one easily recognized symbol that represented Casals—the cello. Erwitt then had to decide how to treat a cello with the same incisive, interpretive approach he would have used had the man who played it been present for the sitting.

The room he chose was the one in which he had planned to photograph Casals. Upon entering it, he was confronted with several photographic puzzles: (1) Balancing exterior light from openings in the portal with the low light existing inside the room; (2) arranging objects in the room, including the cello, into a meaningful composition, and (3) lighting the objects in the room.

The first decision Erwitt made was to use daylight color film. Then he decided to balance the light shining through the portal with an internal light source. He chose two incandescent lights, #2 photofloods, with blue gelatins that would make the photofloods compatible with his daylight film. After arranging the cello and the chairs, he placed the lights at a right angle to the camera-subject axis, taking care that no light fell directly on the side of the cello facing the camera. Emphasizing the texture of the floor, rimming the empty background chair that is dominated by the silhouette of the cello in the foreground, this right-angle lighting added a feeling of depth to the picture—an effect that can easily be achieved by cross-lighting most interior subjects.

"By cross lighting or back lighting," Erwitt says, "you separate planes. Front lighting compresses planes. And cross lighting with lamps of the same color temperature

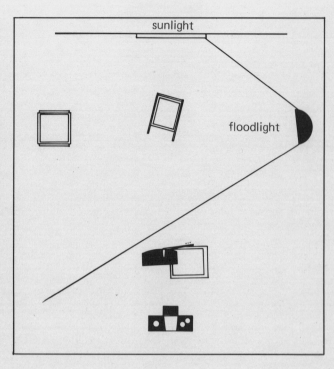

as the primary natural light source allows you to do it without making things look artificial."

The technical accomplishment in this picture was to conceal technique—to make the viewer believe that the cross light came from a window. Seeing one opening for natural light in the picture leads to that assumption, which is reinforced by the quality of the light coming from the side.

Erwitt made the picture with a 55mm lens on an SLR, on Kodachrome (which, at the time he made the picture, had an ASA of 10). His naked eye saw detail in the cello, but to make sure it would photograph almost in silhouette, he previewed the image through a device commonly known as a blue glass. The blue glass, used frequently by cinematographers to preview the effects of incandescent lighting, equals a 3-5 stop neutral density filter, depending on which film the blue glass is made for. Erwitt uses it often when he combines different types of light sources and wants to see the effect before making an exposure.

Blueglass Viewer

COMPRESSING DISTANCE

In his photographs of the island of Corfu (pages 6-7) and the bicyclists in France (page 61), Erwitt's intention was to emphasize the relationship of several objects in the same picture by creating the illusion that they were quite close to one another. The most obvious technique, and the one most commonly used to achieve such an effect, is simply to make the picture with a telephoto lens—which Erwitt did.

The photograph showing a part of Corfu was shot from a nearby hill through a 135mm lens at twilight, at a moment after the sun had passed below the horizon and the daylight was so dim that an incandescent light in the courtyard appeared brighter than the overall light reflected from the sky. This time of day, not completely dark but still dark enough to prompt the lighting of lamps, is known to photographers as the blue hour. The 10 minutes or so that it lasts are a favorite time for making dramatic studies.

Because daylight is so dim at this time, exposure problems are legion. To compensate, Erwitt bracketed his exposure, starting from a shutter setting that would be close to correct for the incandescent light source alone. He set his lens at f/5.6 to get enough depth of field to maintain sharp focus in both foreground and background, and bracketed shutter speeds from 1/4 second to 1/30.

For the symmetrical composition of the French bicyclists and their loaf of bread, Erwitt again compressed distance through the judicious choice of a telephoto lens, in this case a 200mm. To solve the standard problem of telephotography—camera steadiness during exposure—he opted for his standard practice of mounting the camera and lens on a tripod.

To solve a second inherent problem of the telephoto lens—shallow depth of field—Erwitt had his subjects stand still while he carefully prefocused on them. At the same time, he was determining the exact composition of the picture, choosing a camera angle that would place the bicyclists just where he wanted them against the background. He then put down a stone at his focusing point, and gave the signal to the riders to start moving. Each time they moved down the road toward the stone, he clicked his shutter as they came abreast of it. An additional virtue of using such a marker was that it helped the adult rider to hit the same position for each picture.

Erwitt did not need a high shutter speed to stop action, because the subject was moving in the same axis as the lens. If the subject had been moving across the lens axis, of course, he would have had to set the shutter at quite a high speed to freeze all movement.

Critical focus area

MANIPULATING SCALE WITH WIDE-ANGLE LENSES

"The most useful thing about a wide-angle," says Erwitt, "is that it creates relationship between foreground and background. When a background is enormous and something you want to show in the foreground is small, you can reverse the relationship by using a wide-angle lens close to the foreground subject."

"Buckminster Fuller's head is approximately 12 inches in diameter. The geodesic dome we wanted to photograph was more than 100 feet in diameter. Now, what was I going to do?"

Erwitt had not completely visualized the picture when he and Fuller climbed into a helicopter to get a look at the dome from above. He didn't think there would be enough room to take a picture in the two-passenger machine, "but we were close, so I tried." In order to establish the interesting spacial relationship between Fuller and the structure he designed, Erwitt decided to work with an extreme wide-angle mounted on a Leica. Asking Fuller to turn his face, Erwitt shot with a 21mm lens from a little more than a foot away as the helicopter hovered near the dome. At one stroke, he achieved a visual statement with at least three facets: the dome appears to be subordinate to its maker, natural light points up the difference in texture between Fuller's thick glasses and his skin, and the curve of the helicopter's door-frame complements the curve of the dome below while lead-

ing the eye to Fuller's head. The extreme curve of the lens also pulls the image toward the corner, continuing the series of curves in its apparent distortion of perspective on Fuller himself.

One consideration Erwitt had to keep in mind was depth of field, to keep both Fuller and the dome in focus even though they were 1000 feet apart. A fast shutter speed might have protected Erwitt against camera movement caused by the helicopter's vibration, but it would have required a wide aperture (about f/5.6)—and therefore shallow depth of field. Even though the lens's closest focusing point was 24 inches, and Fuller was just 14 inches away, stopping all the way down to f/22 and compensating with a slow shutter speed would have produced enough sharpness to render the foreground and most of the background in focus. But Erwitt did not make the exposure at f/22. The aperture would not have been compatible with the speed of at least 1/125 second that he would have to use because of the vibration; in addition, exposing for the brightness of the dome at f/22 would have cast Fuller in silhouette, so Erwitt compensated by opening his aperture one stop. At f/16, he managed to hold the shadow detail in Fuller and kept the depth of field he wanted.

In another situation, to make the picture of the clock face on pages 66-67, Erwitt used a different camera but identical technique. He composed the photograph on the ground glass of a view camera, looking through a wide-angle lens to balance the sizes of a clock two feet in diam-

eter and a building about 15 stories high. The clock represented time and the building, located in Brazil's new capital city of Brasilia, represented the future; together, they carried the theme of an advertisement for IBM.

As an additional touch, Erwitt did not rely entirely on natural light for this photograph. To separate the outline of the clock from the sky at the left, he set up an artificial light to the right of the picture and aimed it to light one edge of the rim and the numbers.

POINTS OF VIEW: MANY PICTURES IN ONE

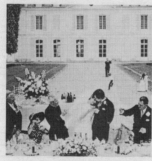

For the photographs on page 64-65, done as advertisements for a brandy distiller, Erwitt was asked to depict an aristocratic French wedding. After visiting a few weddings, he decided not to photograph a real one but to use actors to recreate the elements of a wedding feast that he wished to include in the ad. Erwitt chose to stage his feast in front of a richly appointed château that would allow him a choice of vantage points, each with an interesting background; he wanted the one session to produce material for several different ad layouts. Besides an ability to direct the actors, Erwitt had to call upon several important photo-

graphic techniques to emphasize or de-emphasize certain elements in each picture.

For the horizontal ad, Erwitt decided to concentrate on the people and their emotions by eliminating foreground and background as much as possible. To accomplish this, he first chose a 135mm lens that would not only compress distances but would throw the background partly out of focus. The telephoto's shallow depth of field enabled him to concentrate the viewer's attention on a single subject—in this case, the bride. Also, by shooting from almost the same level as the subject, he suppressed much of the background and foreground. If he had been much higher than the group of celebrants, the ground behind them would have showed. If he had been lower, the sky would have showed. The combination of long lens, shallow depth of field, and careful choice of angle produced a compressed image with a single point of

view.

For the vertical ad, Erwitt wanted a completely different feeling, one that included not only the emotion of the event but also its formality, which could be represented by its physical surroundings. The ritual toast, the symmetry of the lawns and walk, and the architectural formality of the house, all work toward the overall effect. To achieve it, Erwitt reversed the approach he had made to the horizontal picture. He chose a 35mm lens that would give him great depth of field, so that all elements would be in focus. He climbed up a ladder to get a high vantage point that enabled him to include some background and, more importantly, to maintain the relationship of foreground to background. Finally, the wide-angle view did not concentrate on any single element of the picture; it embraced the total environment.

Since the pictures were shot on an overcast day, Erwitt did not need lights to

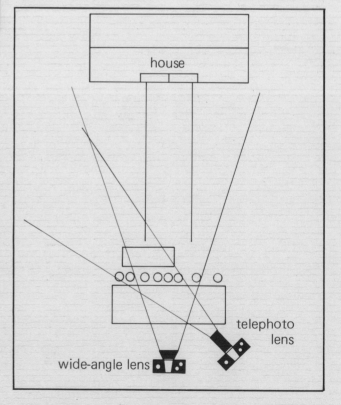

fill harsh shadows. If he had been shooting in direct sunlight, he could have used auxiliary reflectors to fill shadows and soften contrast. Erwitt used his Leica on a tripod to make the pictures. After he had composed them, he took his eye from the viewfinder and looked directly at the subjects, waiting for the correct moment to make his exposures.

THE VIEW CAMERA: A FORMAL TOOL FOR CREATING AN ILLUSION OF INFORMALITY

The picture on pages 68-69 of the church at Wounded Knee, South Dakota, is a prime example of the need for a view camera in certain shooting situations. Under the reduced lighting conditions of the stormy day on which Erwitt made the photograph, it would have been extremely difficult to maintain depth of field from the foreground flowers and grass—only a few inches from the camera—all the way back to the distant horizon.

Swinging and tilting front.

Only the view camera, with its tilting lens board, allows the photographer an almost unlimited ability to manipulate the plane of focus without altering the aperture of the lens. Tilting the lens board allows one to bring many distances into focus without stopping down the aperture—in effect, modifying focus. Here Erwitt used a 47mm Super-Angulon lens. He tilted the lens board at approximately the same angle as the slope of the hill. In doing so, he found he only had to close down to f/8 and was therefore able to shoot at 1/30 second—just fast enough to hold the flowers in the foreground sharp even though they were blowing slightly in the wind. If he had not tilted the lens board and had relied instead on reducing aperture to increase depth of field, he would have required an f/22 lens opening to hold the focus through the entire depth of field; a corresponding shutter speed of 1/4 second would not have held the flowers sharp.

Erwitt faced a similar problem while making the picture on page 75 of the Sicilian hunter with his hounds. A slow shutter speed would not have frozen the unpredictable movement of the dogs. Wanting to hold the entire courtyard in focus to keep the benefits of its design, Erwitt chose to tilt the lens board as he had done in the

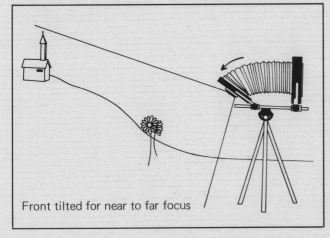

Front tilted for near to far focus

Wounded Knee picture. Here again, overcast lighting precluded his using a small aperture/fast shutter combination for the result he wanted.

Swinging and tilting back. For the picture of the aging Sicilian aristocrat on page 78, Erwitt exploited another important image-control feature of the view camera—the swinging and tilting back that corrects perspective. In this case, Erwitt's vantage point, above the subject and shooting down, would normally have produced an effect of converging parallel lines in the background. He felt that maintaining the structural integrity of strong parallel lines in this aristocratic setting would help him convey the rigid formality of the moment. Even though the lens was pointing downward, Erwitt achieved the composition he wanted by tilting the back of the view camera parallel with the wall. Then he tilted the lens board slightly to compensate for the effect on focus of the tilted film plane.

As in the Casals portrait on page 1, Erwitt simulated side window lighting with floodlights to augment the existing diffused room light, which was coming primarily from behind the camera. He also used his blue glass to preview the contrast of the scene as it would appear on film.

Rising and falling front. A third control feature of the view camera is the lens board that can be raised and lowered without tilting the camera.

Erwitt used this feature for the photograph on pages 70-71 of the building designed by Mies van der Rohe. From his vantage point on the ground, he would have been unable to include the top of the structure with an ordinary camera without tilting the camera upward. If he had tilted the lens upward, the parallel structural lines of the building would have converged in an effect referred to as "keystoning."

The simple way to circumvent this problem is to keep the view camera level with the ground and to raise the lens board so that the topmost point of the subject appears on the ground glass. Since the only way to focus a view camera is to look at the image the lens throws on the ground glass, this is the picture that will appear on the film. Why doesn't raising the lens to cover the top of the building cut off the bottom of the building? Simply because most lenses designed for view cameras have a greater field of view than the area actually encompassed by the film frame. Lenses designed for view cameras usually have about half again as much "covering power" than is needed in a straight-

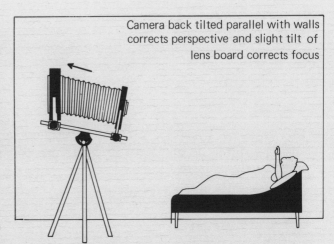

Camera back tilted parallel with walls corrects perspective and slight tilt of lens board corrects focus

on shot. Their optics are designed to give the image a border, so to speak, into which a photographer can swing or tilt a lens.

Smaller-format cameras such as the 35mm use fixed-position lenses that produce an image precisely the size of the film frame. Lenses for such cameras are designed without extra covering power. Several exceptions emerged in the early 1970s, to satisfy the needs of professional 35mm photographers such as Erwitt; his Canon 35mm "tilt & swing" and the 28mm Nikkor are examples.

Even after the top of the Mies building is framed by a comfortable strip of blue sky, Erwitt's view camera left him room to include a passerby on the sidewalk, to give an indication of scale. "You really need something like a human being to give some idea of the size of a building."

He had the same problem with the snowbound house on pages 72-73, and solved it by raising the lens board slightly. Again, he set up the camera, composed the picture, then waited for a figure to come along to give some notion of the size of the house. "You always wait for something," Erwitt says, "and something always happens. A bird flies by, a horse comes along.... Without the horse, it's just another picture. With the horse, it has character, I think, and mood.

"When I shoot architecture I'm not always just trying to make a beautiful image. The house might have been enough by itself; then the horse walked in. I do like to make it a representational picture. But anything I can add to it helps."

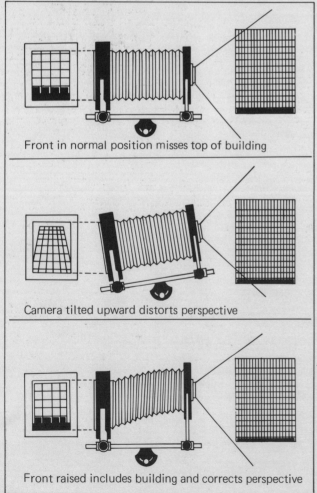

Front in normal position misses top of building

Camera tilted upward distorts perspective

Front raised includes building and corrects perspective

One of Erwitt's favorite sets of pictures comes out of a *Holiday* story he did on European nudist camps. Nudists are naturally funny subjects for Erwitt's camera, and he played the game fairly by becoming one himself. Without clothes his subjects seem to work harder at affecting stereotype images. The circumstance is ripe with all the built-in elements characteristic of his photography — irony, subtlety and a picaresque humor which he uses to puncture our foibles.

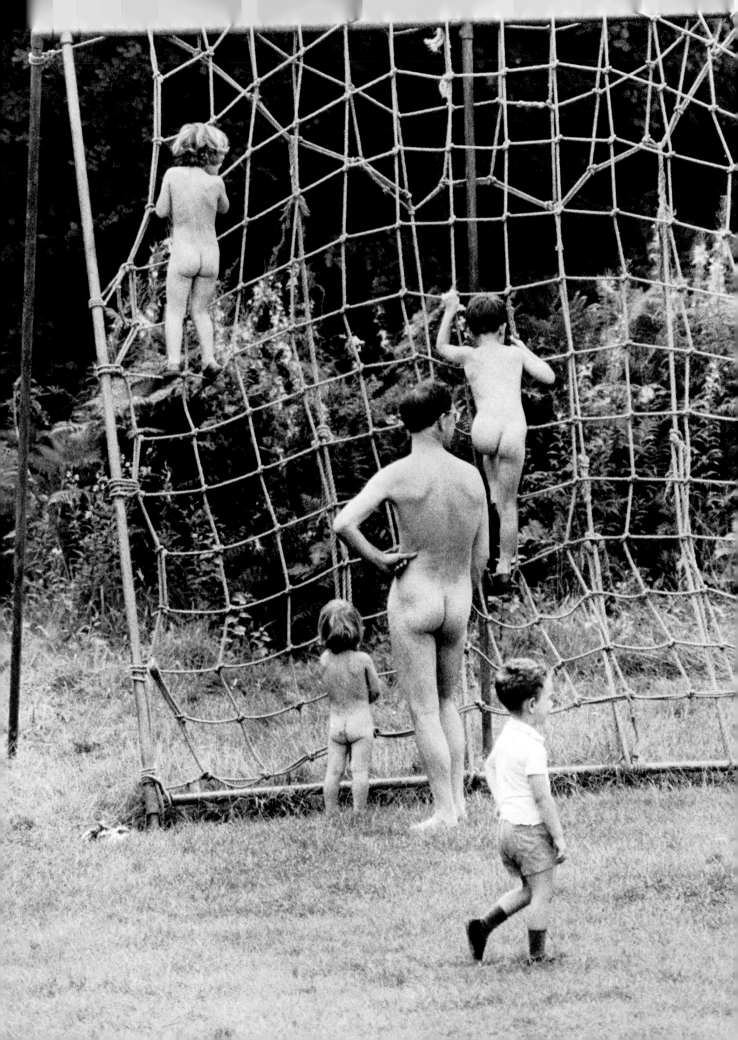

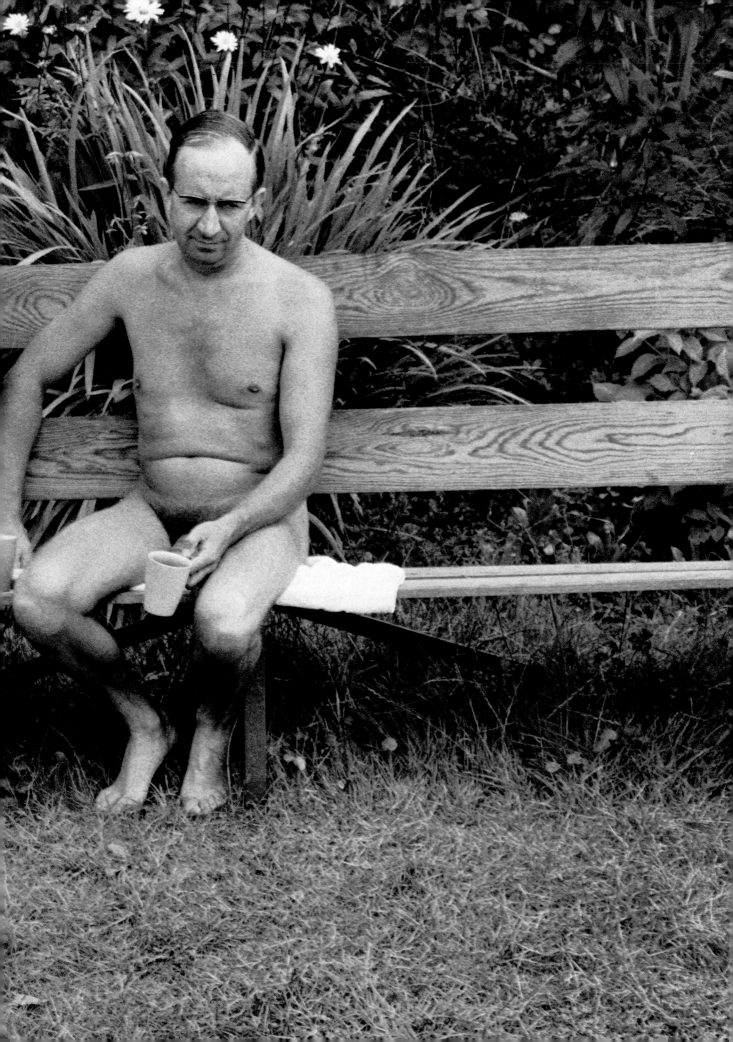

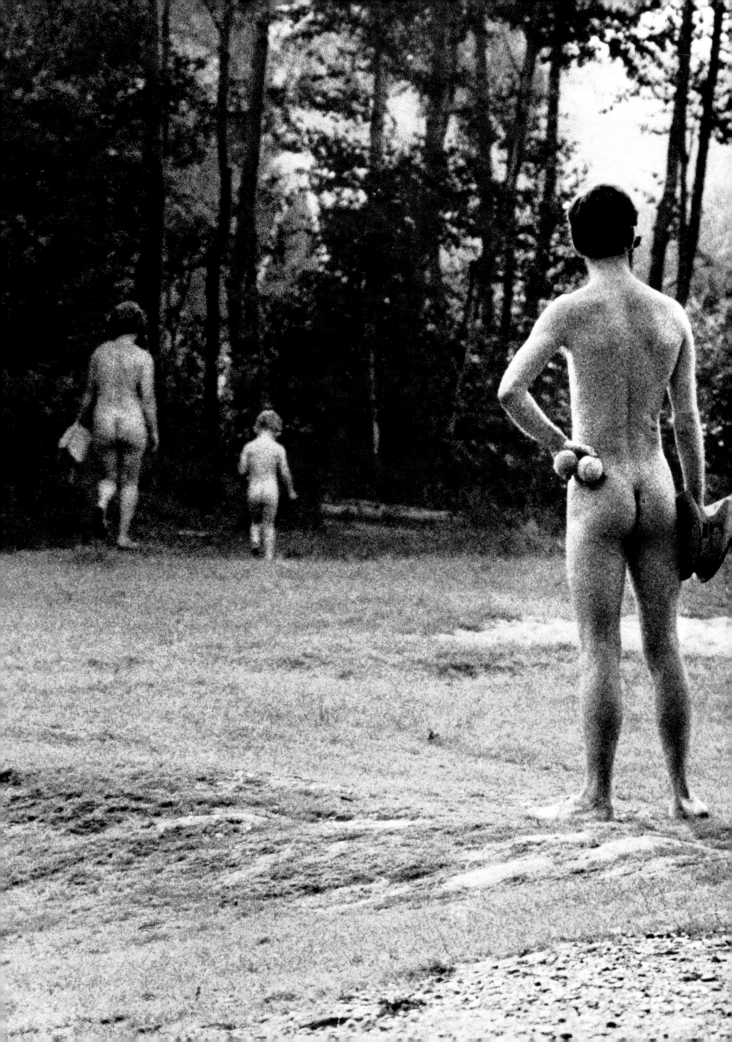

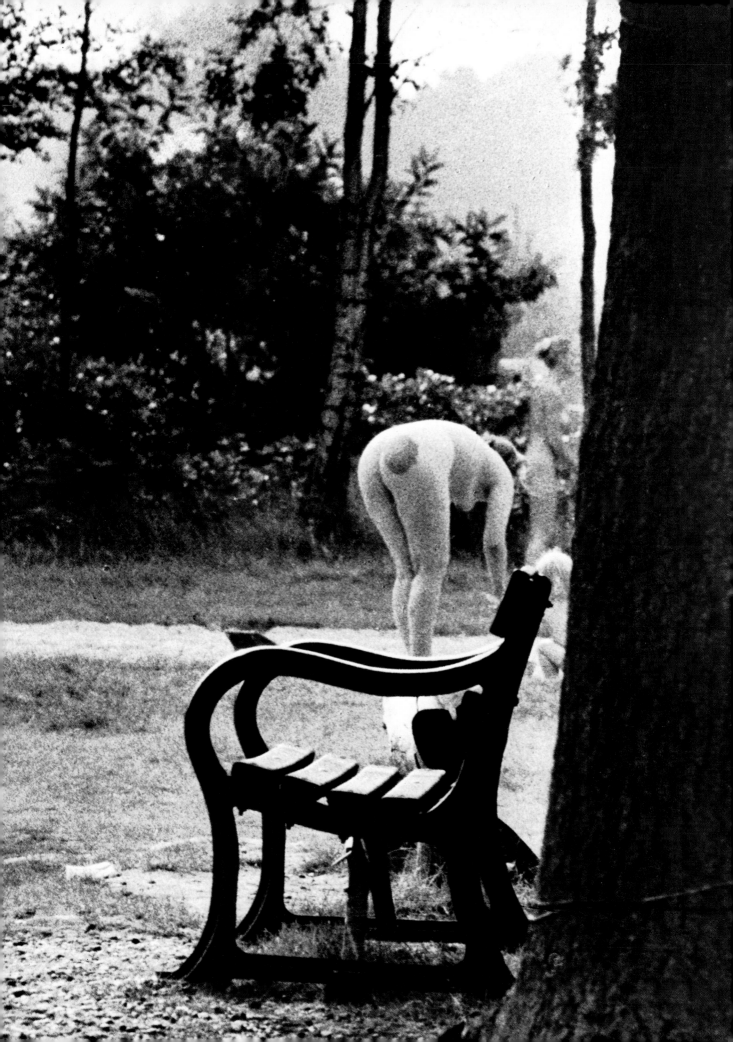

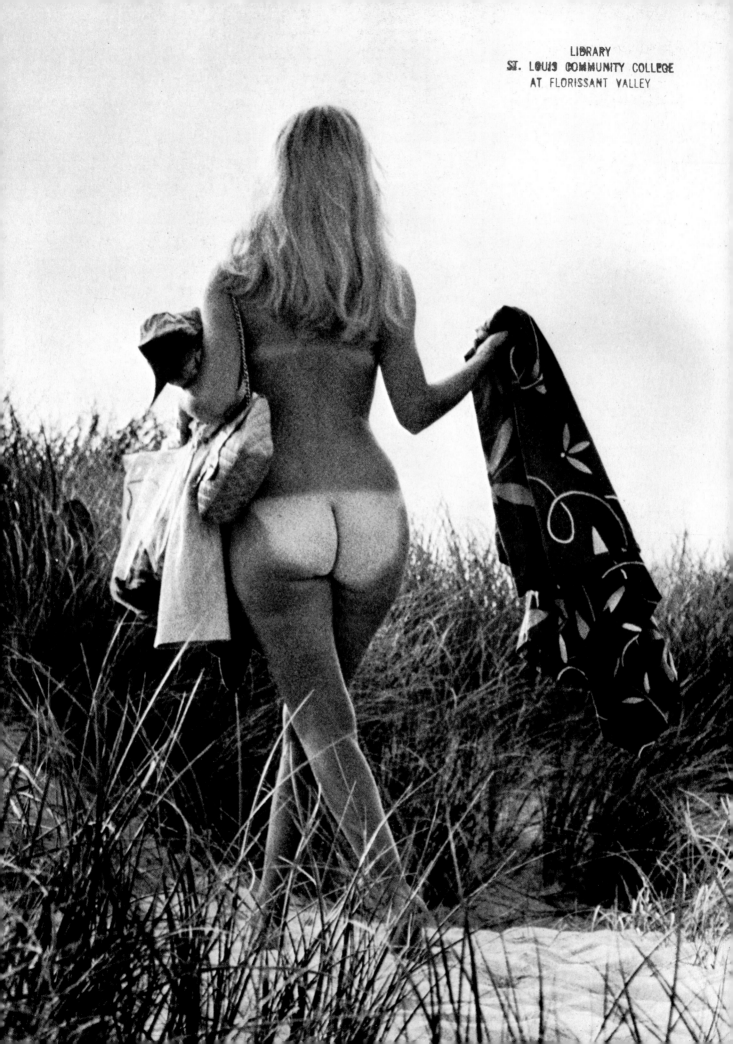